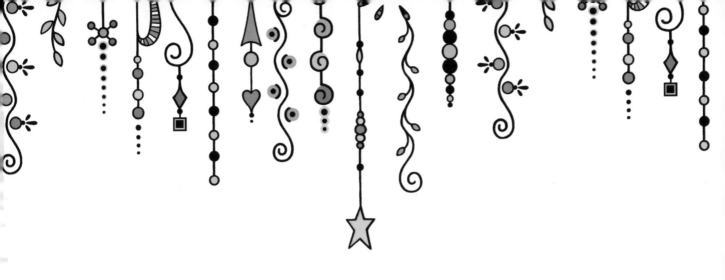

THE ART OF DRAWING

Dangles

CREATING DECORATIVE LETTERS
AND ART WITH CHARMS

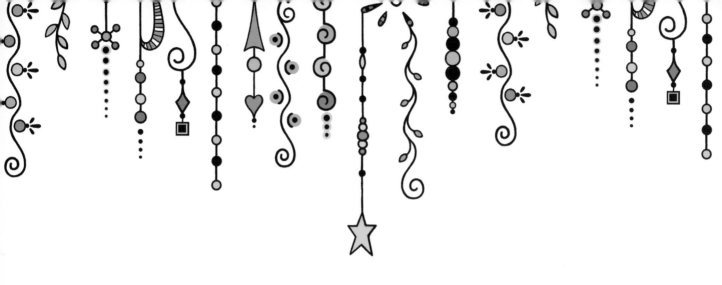

THE ART OF DRAWING

Dangles

CREATING DECORATIVE LETTERS AND ART WITH CHARMS

Olivia A. Kneibler

Race Point
PUBLISHING

Inspiring | Educating | Creating | Entertaining

Brimming with creative inspiration, how-to projects, and useful information to enrich your everyday life, Quarto Knows is a favorite destination for those pursuing their interests and passions. Visit our site and dig deeper with our books into your area of interest: Quarto Creates, Quarto Cooks, Quarto Homes, Quarto Lives, Quarto Drives, Quarto Explores, Quarto Gifts, or Quarto Kids.

© 2017 by Olivia A. Myers

First published in 2017 by Race Point Publishing,
an imprint of The Quarto Group
142 West 36th Street, 4th Floor
New York, NY 10018 USA
T (212) 779-4972 F (212) 779-6058
www.QuartoKnows.com

All rights reserved. No part of this book may be reproduced in any form without written permission of the copyright owners. All images in this book have been reproduced with the knowledge and prior consent of the artists concerned, and no responsibility is accepted by producer, publisher, or printer for any infringement of copyright or otherwise, arising from the contents of this publication. Every effort has been made to ensure that credits accurately comply with information supplied. We apologize for any inaccuracies that may have occurred and will resolve inaccurate or missing information in a subsequent reprinting of the book.

Race Point titles are also available at discount for retail, wholesale, promotional, and bulk purchase. For details, contact the Special Sales Manager by email at specialsales@quarto.com or by mail at The Quarto Group, Attn: Special Sales Manager, 401 Second Avenue North, Suite 310, Minneapolis, MN 55401, USA.

ISBN 978-1-63106-325-1

Editorial Director: Jeannine Dillon
Managing Editor: Erin Canning
Project Editor: Jason Chappell
Designer: Melissa Gerber

10 9 8 7 6 5

Printed in China

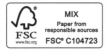

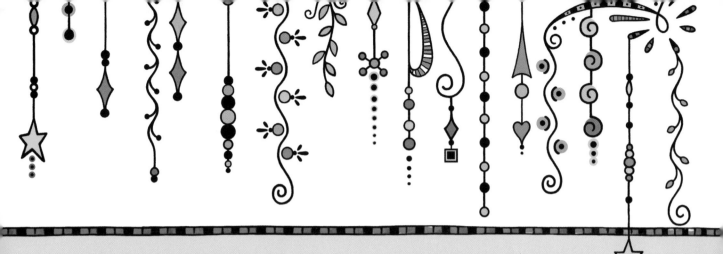

Contents

What Is a Dangle?

Dangles are beautiful illustrated strings of charms that you can use to decorate letters, shapes, and objects. They are the perfect ornamentation to any drawing because there are no set boundaries for what they are. The only limit is your imagination. Dangles can hang gracefully from the top of note cards and stationery, they can wrap around letters, they can shoot upward from an artwork, and more. What makes a dangle interesting are the unique charms you can add to them, be it a heart, diamond, circle, arrow, cloud, square, swirl, or whatever you want. You can personalize each dangle and charm to your taste.

Drawing dangles is a relatively simple process. First, decide what you want to create and how you want to arrange your charms to illustrate your artwork. If you are creating an organic mandala, for example, you might select dangle charms like vines and flowers to reinforce the idea. Next, decide whether the charms should be the centerpiece of the drawing, or if they should simply accentuate the art and not overwhelm it.

Below is a short tutorial to help you get started making your own charms that you can use to create dangles. Chapters in this book will guide you through the process of drawing charming dangle letters and words, and adding charms to basic geometric shapes and illustrations of everyday objects. Each project is intended to serve as inspiration and practice for your own original dangle artwork. The only limit to what you can do with these charms is your own imagination: experiment and have fun!

DRAWING A DANGLE

Begin by deciding on the type of line you would like to use for your dangle. The line style can help determine the mood of a piece since each type of line can evoke different emotions and style, which will impact the way a viewer sees and feels about your creation. Wavy lines tend to carry a sense of inner peacefulness, while straight lines convey a sense of rigidity. Swirly lines carry a lot of motion and whimsy.

For example, if I were going to draw a sunset, I might use straight lines to convey the individual rays of sunlight beaming out from the sun. If I were to draw an ocean, I might use the wavy lines to illustrate the calm feeling that water often evokes. If I were to draw a breezy spring flower garden, I might use all three line types: straight lines for the flower stems, wavy lines for the soft petals, and swirly lines to give viewers a sense of that incredible spring breeze.

Select line styles that enhance and complement your overall creation. Feel free to unleash your creativity here and deviate from standard lines in your pieces. Here are some basic lines to get you started, but you can always experiment with other line constructions and see how they make you feel.

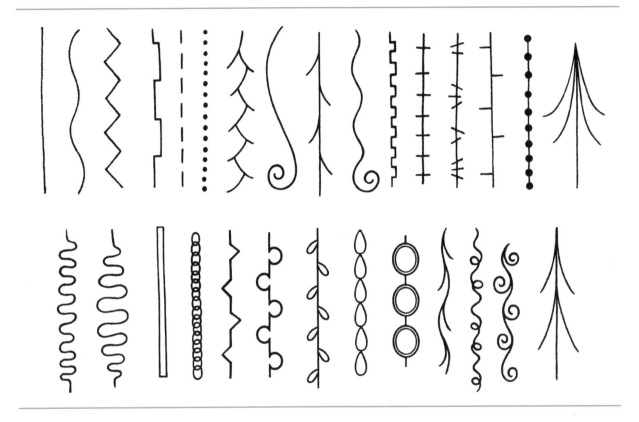

Once you have drawn the starting line to your dangle, decide whether your composition will benefit from a shape charm. Shape charms can be placed anywhere on your starting line, or they can be placed along the whole line if desired.

Think about what you want to convey with your art. For example, if you want to enhance the organic qualities of your drawing to add a sense of nature to your piece, try adding flowers and raindrops. If you just want to add bling, add diamonds and hearts. Consider the connotations of each shape, but also remember that the unique charms you add to your dangle are what make it personal. Sometimes, the charm additions end up being the true conversation piece of the final image.

Another thing to consider is how to add multiple shapes to lines to create patterns and impressions. For example, if you want your line to resemble a wrought-iron fence post, you can add a triangle with a circle to both ends of a straight line. Vines are simply straight lines with little ovals attached to the line like leaves. This vine can then easily flow from your drawing by extending the line with a short loop to connect it. The most important part of creating a dangle is finding a way to connect it to your overall drawing.

The best part of creating a dangle is adding fun messages using different shapes and charms. If you are illustrating a card for a loved one, perhaps you can spell out the word "LOVE" and add ornate hearts, roses, or other love-related charms. Love doesn't have to be represented in one way, either: Below, new love (as shown by the hearts), permanent love (as depicted by the wedding motifs), and the end of love (as illustrated by the broken hearts) are shown.

Dangles are an easy, fun way to get your creativity flowing and to accentuate your art and letters. Take the art and suggestions in this book as inspiration and see what you come up with that is unique to you. Most of all, enjoy the process!

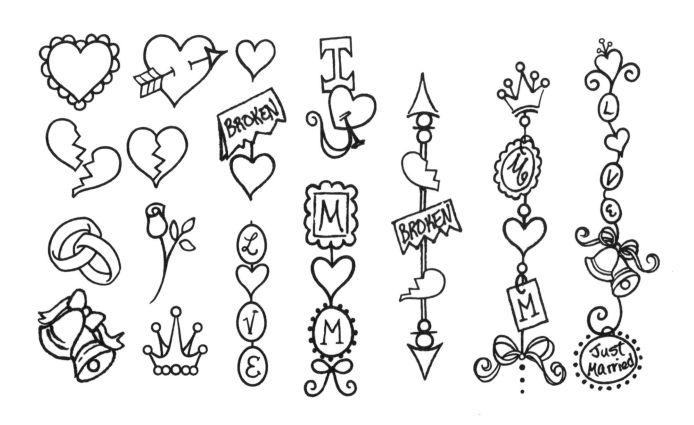

RECOMMENDED MATERIALS

I have given some recommendations here for materials and brands, but the key is to experiment and see what works best for you.

PENCILS

I always start my drawings using a mechanical pencil with a thick lead, either 0.7 mm or 0.9 mm, because the first lines are typically guidelines and will be erased later. Expensive artist pencils are a waste here because you're just going to erase the lines. Once you've drawn the guidelines and are beginning the drawing, mechanical pencils are still preferable because they always have a consistent line width. As for brands, I prefer Bic and Paper Mate mechanical pencils because I find that they are smooth and don't feel scratchy or rough on paper.

ERASERS

The only eraser that I trust for drawing dangles is the Pink Pearl Eraser because it does an excellent job of completely erasing pencil lines, and it doesn't weaken the paper.

BLACK MARKERS

Once I'm satisfied with my pencil line drawings, I use an ultrafine point Sharpie to draw outlines. For heavier lines, a fine point Sharpie is also acceptable. They are the only markers that don't run into the grain of the paper, even when wet. Sharpies will bleed through most thin and medium thickness papers, so add a piece of scrap paper beneath your work to avoid the Sharpie bleeding onto something important.

WATERCOLOR PAINTS

My preferred medium for coloring a dangle is watercolor paint. It's easy to create countless effects with watercolors, from soft and airy touches to seamlessly blending colors. Unlike other coloring media, watercolors are heavily dependent on the paper type you are using and can be messy, so I sometimes opt for colored pencils or markers instead. My preferred watercolor brands are Grumbacher, Van Gogh, and Winsor & Newton, because they all contain nontoxic materials and wide color diversity.

COLORED PENCILS

I like my colored pencils to flow smoothly across paper, so I prefer Prismacolor Premier Soft Core pencils, which are wax pencils, and Faber-Castell Polychromos pencils, which are oil.

COLORED MARKERS

I prefer Copic markers because they have a huge variety of colors and various tip thicknesses for each color. They are known for the Copic Original markers that have two ends, one with a large nib for coloring large areas, and one with a fine nib for detailed work.

PAPER

For drawing thumbnails, roughs, and sketches, I use any brand of printer or copier paper. This paper is inexpensive, has a smooth finish, and is easily recyclable. For drawing final pieces, my favorite paper is the Strathmore Bristol pad with smooth finish, and specifications of at least 100 lbs. (270 g/m²) and 300 series or higher. The paper is thick enough that even Sharpies rarely bleed through it and smooth enough that thin line markers don't get lost.

Dangle Letters

\mathcal{I}t's easy to draw dangle letters once you figure out where to start. One of the keys to drawing a beautiful dangle letter is to sketch your letter outline with some dimension (see Fig. 1) so you have space inside of it to add color and patterns.

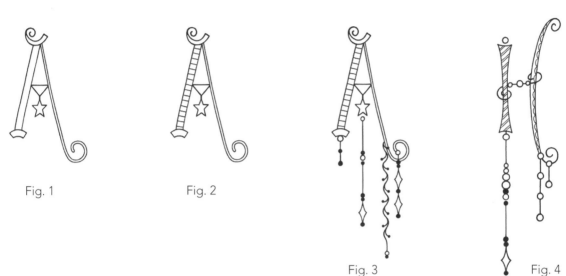

Fig. 1

Fig. 2

Fig. 3

Fig. 4

Once you draw the outline of your letter (see Fig. 1), take a step back and look at it again. Changes to the shape and size of the letter after this point become more difficult because you will be adding patterns, so make sure you are happy with it.

Next, you can add a pattern to your letter. Types of patterns can range from simple dots and stripes to checkers or even paisley. The easiest spot to add pattern is in the widest section of your letter (see Fig. 2), and you don't need to stick to just one pattern. Experiment with clashing your patterns for a dramatic effect.

Now that you have your letter drawn and your patterns added, you can accessorize your letter with dangles! Hang your dangle threads from the lines and flourishes of your letter. Try to keep the length of the charms in proportion with the letter itself (see Fig. 3). For example, you want

to avoid drawing a large, wide charm beneath a thin lowercase letter because you run the risk of making the letter or word difficult to read. Also, while the word "dangle" implies that the charm threads must hang below the letter, dangles can go down, up, or even sideways (see Fig. 4).

Most of the dangles in this book contain charms like diamonds, hearts, and stars. For inspiration on drawing charms, turn to the Charm Directory (page 120). You can use the charms I've included in the book or create your own unique charms. If you are drawing the name of a child who loves trains, for example, perhaps you add wheel charms or create a smoke dangle coming out of a letter.

The final step of drawing a charming letter is to color it in! Have fun and be inspired by the Color Gallery (page 134).

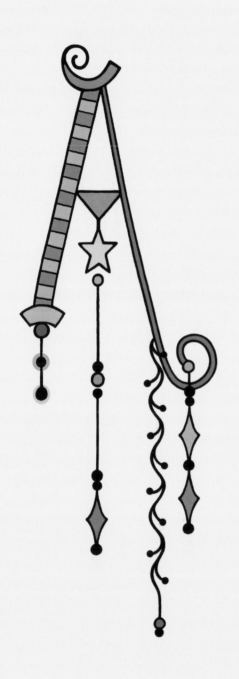

1. Curls and swirls can take an ordinary letter from boring to exciting.

2. These simple dots and circles can add dimension to flat letters.

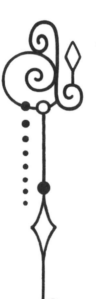

3. Now it's your turn! Practice the letter lines by outlining the letter on the right. Add dangles like the ones I drew (left), or create your own unique dangles!

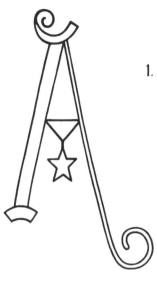

1. Stars add visual interest to your letter outline and can also act as an anchor to hang charms from.

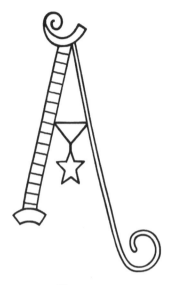

2. The simple line pattern in this example helps to accentuate the curves by providing a sharp contrast to them.

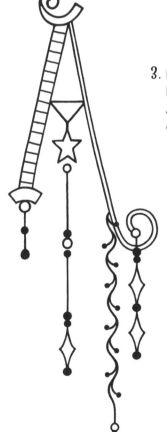

3. Now it's your turn! Practice the letter lines by outlining the letter on the right. Add dangles like the ones I drew (left), or create your own unique dangles!

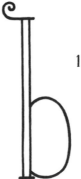

1. In contrast to the uppercase letter on the opposite page, the lowercase letter is dominated by straight lines, with the exception of the little flourish at the top.

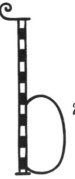

2. A simple pattern not only adds visual interest, but it also provides a handy way to add more colors later.

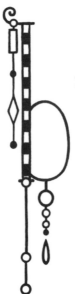

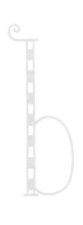

3. Now it's your turn! Practice the letter lines by outlining the letter on the right. Add dangles like the ones I drew (left), or create your own unique dangles!

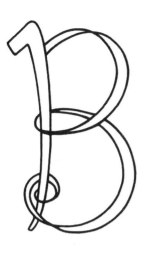

1. This letter has almost no straight edges. This works well for dangle artwork because curves add drama and more possibilities for hanging charms.

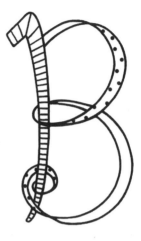

2. You can definitely use contrasting patterns, like dots and lines, but try to avoid overwhelming your artwork with pattern. An accent pattern in one area contrasts nicely with an area left without pattern.

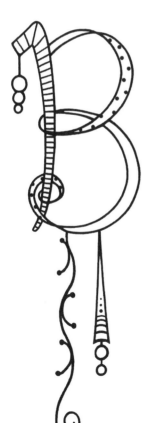

3. Now it's your turn! Practice the letter lines by outlining the letter on the right. Add dangles like the ones I drew (left), or create your own unique dangles!

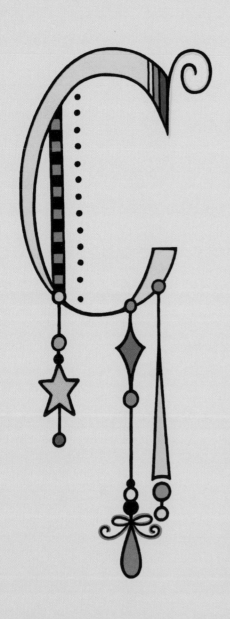

1. Sometimes simplicity is best, especially if you're going for elegance. Keep it simple, with a swirling "c" and a serif ending.

2. The straight lines added in this step contrast sharply with the swirling curves of the letter.

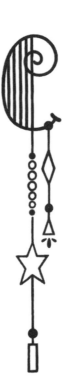

3. Now it's your turn! Practice the letter lines by outlining the letter on the right. Add dangles like the ones I drew (left), or create your own unique dangles!

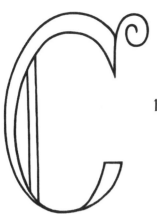

1. Try adding bars like the one added to the "C" here to break up large, open spaces.

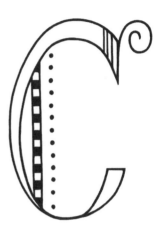

2. Less is more! You don't have to fill an entire space with a pattern. Sometimes the letter looks better with just a few lines added, like in the upper part of the "C" shown here.

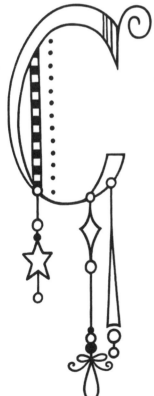

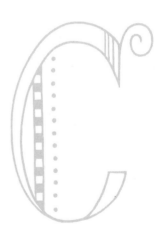

3. Now it's your turn! Practice the letter lines by outlining the letter on the right. Add dangles like the ones I drew (left), or create your own unique dangles!

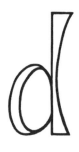

1. You can transform a simple and traditional design like this one by adding patterns and charms later.

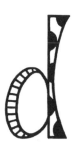

2. Choose bold patterns for small spaces. These polka dots are reminiscent of cow spots!

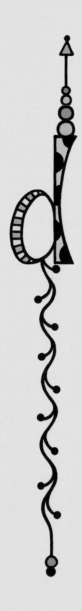

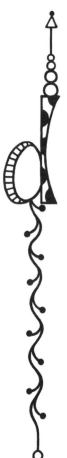

3. Now it's your turn! Practice the letter lines by outlining the letter on the right. Add dangles like the ones I drew (left), or create your own unique dangles!

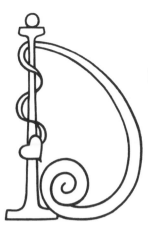

1. Not sure how to end a flourish or curve? Trying adding a charm! The heart on this letter is a nice way of covering the end of the snaking curve.

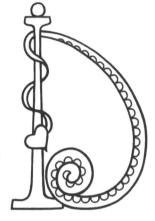

2. This letter is already visually intense, so sticking with a simple pattern, like these scallops inside the curve, is effective.

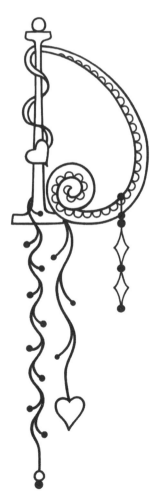

3. Now it's your turn! Practice the letter lines by outlining the letter on the right. Add dangles like the ones I drew (left), or create your own unique dangles!

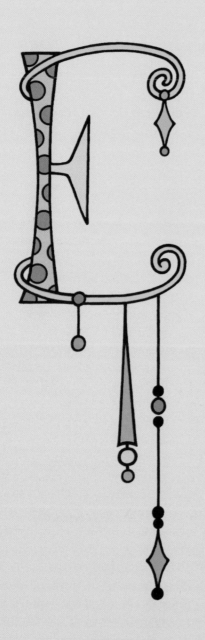

1. This simple outline almost looks like a traditional "e," except that it lacks a cutout in the center, which gives it a hand-lettered feel.

2. You can use a pattern or color to fill in the space of the missing cutout.

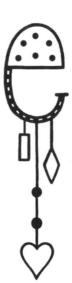

3. Now it's your turn! Practice the letter lines by outlining the letter on the right. Add dangles like the ones I drew (left), or create your own unique dangles!

1. The "E" shape combines a few sharp edges with lots of curves.

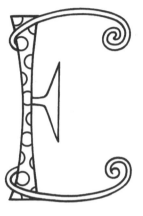

2. Adding a fun pattern of dots to the rigid lines in the "E" helps to create a whimsical balance.

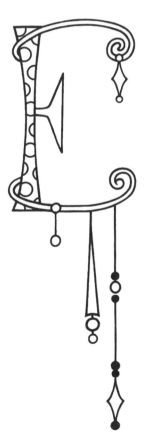

3. Now it's your turn! Practice the letter lines by outlining the letter on the right. Add dangles like the ones I drew (left), or create your own unique dangles!

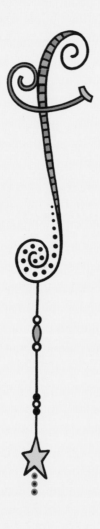

1. Too many swirls can make it difficult to read a letter. Go with a simple serif at the end, like I did here at the end of the crossbar.

2. Use dots to help accentuate and fill curves.

3. Now it's your turn! Practice the letter lines by outlining the letter on the right. Add dangles like the ones I drew (left), or create your own unique dangles!

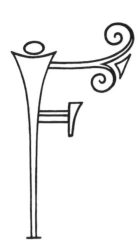

1. This outline is more ornate than some other letters, but you can see that it provides a good platform for adding dangle glamor later.

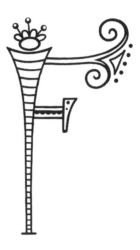

2. I turned the dot floating above the letter into a flower-like crown, which gives the letter a regal look.

3. Now it's your turn! Practice the letter lines by outlining the letter on the right. Add dangles like the ones I drew (left), or create your own unique dangles!

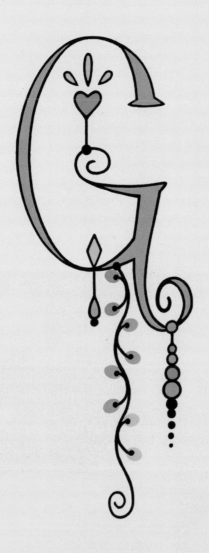

1. This outline diverges from the standard "g" form with the addition of tightly curling ends.

2. The two curved lines inside the "g" give it some motion, along with the horizontal pattern lines.

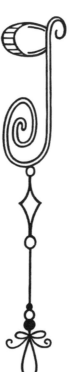

3. Now it's your turn! Practice the letter lines by outlining the letter on the right. Add dangles like the ones I drew (left), or create your own unique dangles!

1. This relatively simple outline relies on classic serifs, with some modern swirls added in.

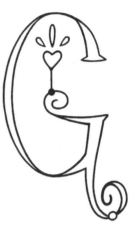

2. Mix up your direction! This is a great example of a heart charm dangle that sticks upward instead of hanging down.

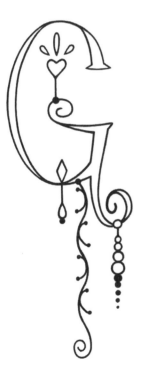

3. Now it's your turn! Practice the letter lines by outlining the letter on the right. Add dangles like the ones I drew (left), or create your own unique dangles!

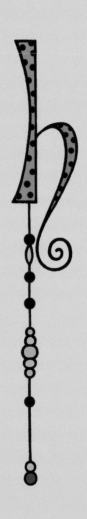

1. Try drawing elements, like this swirl, below the baseline to enhance visual interest.

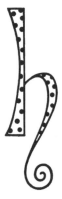

2. This simple polka-dot pattern adds an element of whimsy into a small space.

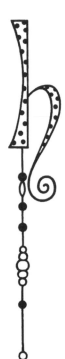

3. Now it's your turn! Practice the letter lines by outlining the letter on the right. Add dangles like the ones I drew (left), or create your own unique dangles!

1. It is easiest to draw this "H" by beginning with the two vertical side elements and then connecting them with the horizontal dangle flourish.

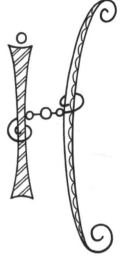

2. The patterns in each of the side elements are dramatically different, but clashing patterns can look bold and dramatic.

3. Now it's your turn! Practice the letter lines by outlining the letter on the right. Add dangles like the ones I drew (left), or create your own unique dangles!

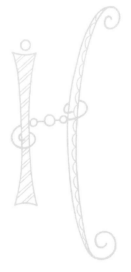

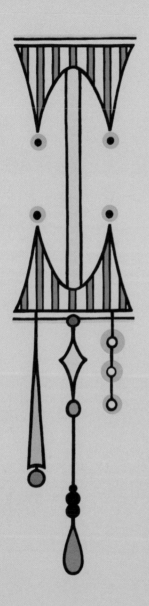

1. This playful take on the letter "i" uses three stacked circles of decreasing size in place of the single dot over the traditional letter form.

2. This simple horizontal line pattern adds a nice contrast to the circles above.

3. Now it's your turn! Practice the letter lines by outlining the letter on the right. Add dangles like the ones I drew (left), or create your own unique dangles!

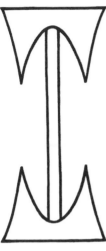

1. Dramatic serifs on the capital "I" provide great platforms for dangles.

2. The floating dots accentuate the dramatic points of the serifs and draw your focus inward to the center of the letter.

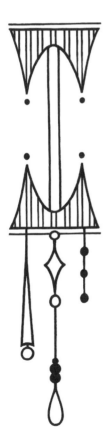

3. Now it's your turn! Practice the letter lines by outlining the letter on the right. Add dangles like the ones I drew (left), or create your own unique dangles!

1. The dot of the "j" almost resembles a dangle because of the way it is connected to the main curve of the letter. Experiment with a nontraditional take on a classic "j" form!

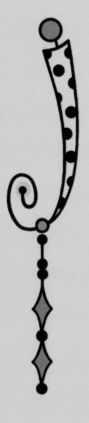

2. The polka-dot pattern is not only fun, but it also mimics the circle on top of the letter.

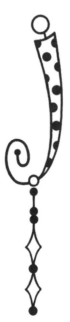

3. Now it's your turn! Practice the letter lines by outlining the letter on the right. Add dangles like the ones I drew (left), or create your own unique dangles!

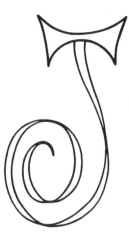

1. The "J" outline contains only curves; there are no straight lines.

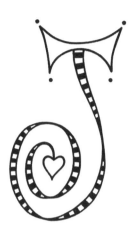

2. It almost looks like main curve of the letter is paper thin and twisting in the breeze, because the black-and-white pattern makes it resemble film tape.

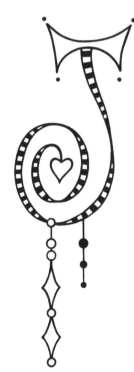

3. Now it's your turn! Practice the letter lines by outlining the letter on the right. Add dangles like the ones I drew (left), or create your own unique dangles!

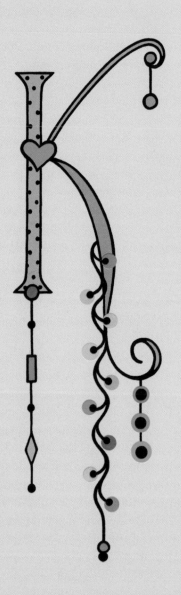

1. This outline follows a traditional "k" form with the addition of a small curl.

2. You can make stripe patterns appear different from each other by giving one a heavier line weight, like I did here.

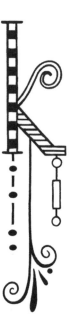

3. Now it's your turn! Practice the letter lines by outlining the letter on the right. Add dangles like the ones I drew (left), or create your own unique dangles!

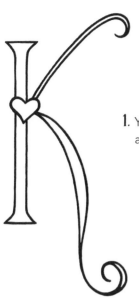

1. You can add charms, like the heart shown here, at any point in your drawing process.

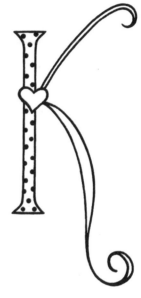

2. Try leaving some parts of letters without a pattern.

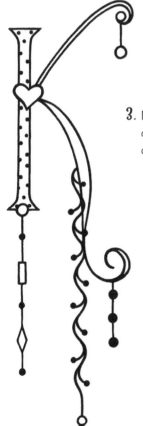

3. Now it's your turn! Practice the letter lines by outlining the letter on the right. Add dangles like the ones I drew (left), or create your own unique dangles!

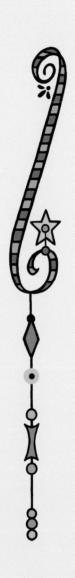

1. This "I" outline mimics a cursive letter with the simple flourishes on each end.

2. When adding a pattern in a space like this, consider the perspective. Although it looks like the stripe pattern is curving toward the flourished ends, they are actually straight lines within each curved flourish.

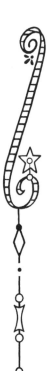

3. Now it's your turn! Practice the letter lines by outlining the letter on the right. Add dangles like the ones I drew (left), or create your own unique dangles!

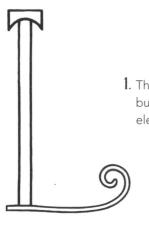

1. The serifs make this a traditional lettering outline, but the curving end on the bottom adds a playful element.

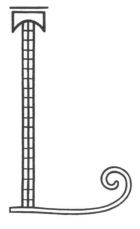

2. The bold line above the "L" reinforces the serif and adds structure to the artwork.

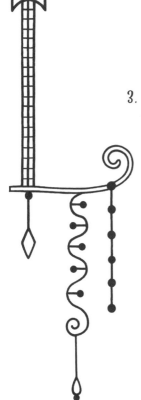

3. Now it's your turn! Practice the letter lines by outlining the letter on the right. Add dangles like the ones I drew (left), or create your own unique dangles!

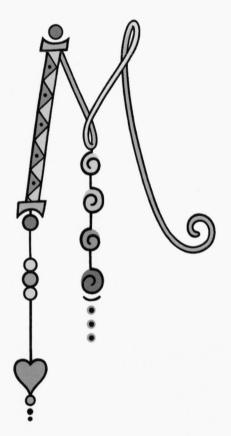

1. The jagged lines at the bottom of the letter add a fun design element and provide some movement.

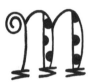

2. I used a simple spot pattern to contrast with the zigzags at the bottom of the "m" for balance.

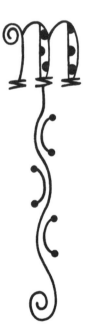

3. Now it's your turn! Practice the letter lines by outlining the letter on the right. Add dangles like the ones I drew (left), or create your own unique dangles!

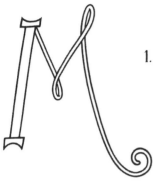

1. To give the illusion that the thinner line of the "M" is one continuous line, you'll actually need to stop your pen when the line loops behind itself. It might take a little practice, but it is a beautiful little trick if you can master it.

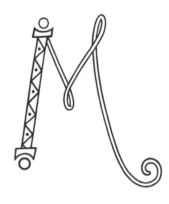

2. Add dots and lines in select spots to enhance the overall composition.

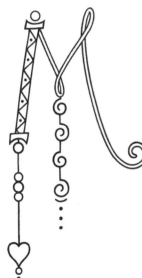

3. Now it's your turn! Practice the letter lines by outlining the letter on the right. Add dangles like the ones I drew (left), or create your own unique dangles!

1. The thin, curving line on the right side of the "n" extends well below the baseline, adding a lower flourish to a letter that traditionally doesn't have one.

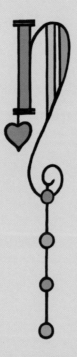

2. The vertical lines inside the curve of the "n" act as supports for it. The more lines you draw, the more colors you can use for the spaces between them.

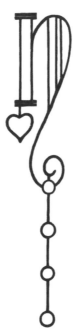

3. Now it's your turn! Practice the letter lines by outlining the letter on the right. Add dangles like the ones I drew (left), or create your own unique dangles!

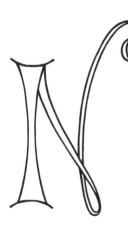

1. This letter mimics the style of the uppercase "M" on page 37, with a single continuous ribbonlike curve.

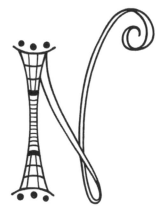

2. Dots accentuate the thin serifs on the letter, and the combination of curved horizontal and vertical lines within the "N" outline creates a weblike pattern.

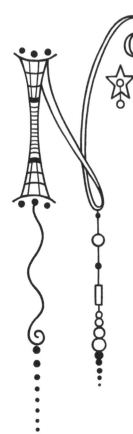

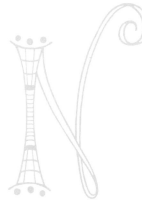

3. Now it's your turn! Practice the letter lines by outlining the letter on the right. Add dangles like the ones I drew (left), or create your own unique dangles!

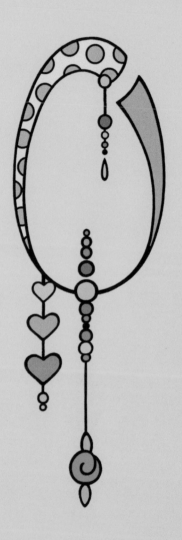

1. With the exception of the decorative swirl inside the "o," this is a fairly traditional outline.

2. The heart breaks up and softens the dot pattern while adding a strong graphic element.

3. Now it's your turn! Practice the letter lines by outlining the letter on the right. Add dangles like the ones I drew (left), or create your own unique dangles!

1. The "O" is traditionally a closed loop, but feel free to experiment and see what looks good!

2. By making the bottom of the "O" very thin, you can add a pattern to just a portion of the letter instead of the whole thing.

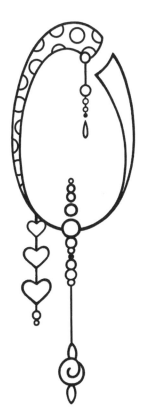

3. Now it's your turn! Practice the letter lines by outlining the letter on the right. Add dangles like the ones I drew (left), or create your own unique dangles!

1. The curved lines in the center of the "p" give the letter a "vibrating" feel.

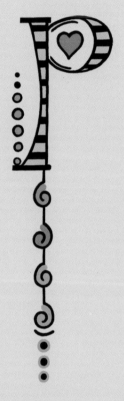

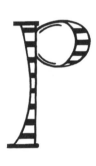

2. The thick black lines within the outline give the letter more structure and rigidity.

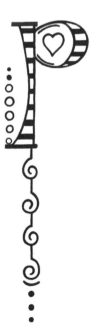

3. Now it's your turn! Practice the letter lines by outlining the letter on the right. Add dangles like the ones I drew (left), or create your own unique dangles!

1. Vary the weight distribution of your letters for a dramatic effect, as done here with the thin spiral and contrasting solid base of the "P."

2. The more complex you make your patterns in this step, the more detail you can color in later. I've mixed three patterns here for dramatic effect.

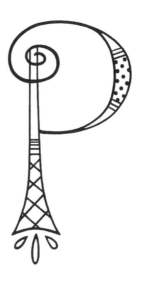

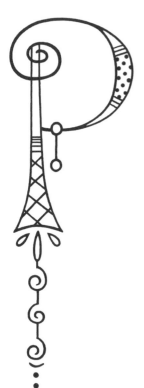

3. Now it's your turn! Practice the letter lines by outlining the letter on the right. Add dangles like the ones I drew (left), or create your own unique dangles!

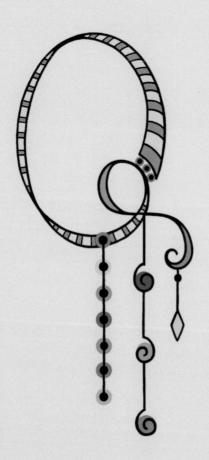

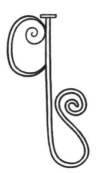

1. The outline of the "q" maintains a fairly consistent width throughout, so it is more readable.

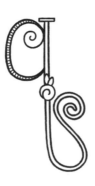

2. Charms don't always need to be on a dangle. The flourish in the middle of the letter is a simple adornment that evokes the idea of flowers or fruit.

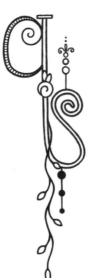

3. Now it's your turn! Practice the letter lines by outlining the letter on the right. Add dangles like the ones I drew (left), or create your own unique dangles!

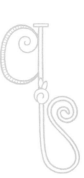

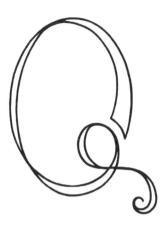

1. This letter can be drawn without removing your pencil from the page. Experiment and see what results you get.

2. Try drawing this pattern all the way around the "Q" outline, taking care to notice that the lines are slightly curved and the pattern gets tighter in the narrower parts of the letter.

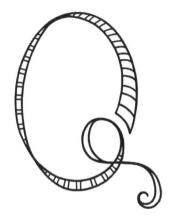

3. Now it's your turn! Practice the letter lines by outlining the letter on the right. Add dangles like the ones I drew (left), or create your own unique dangles!

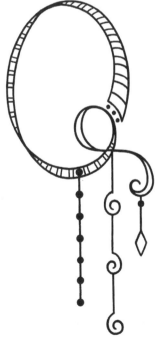

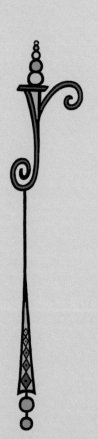

1. This simple outline replaces traditional serifs with swirls.

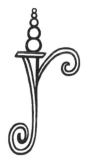

2. The singular serif acts as a platform for this upward vanishing circle dangle.

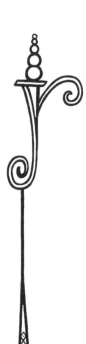

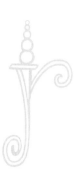

3. Now it's your turn! Practice the letter lines by outlining the letter on the right. Add dangles like the ones I drew (left), or create your own unique dangles!

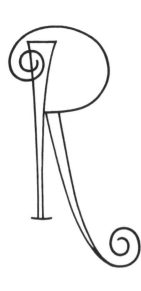

1. Experiment with and without cutouts for the center of the "R." You can even use a charm for the cutout.

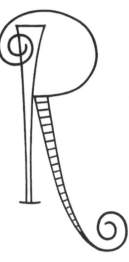

2. The simple horizontal stripe pattern almost looks like a ladder climbing up the "R," drawing the eye upward.

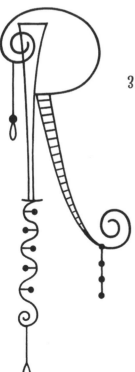

3. Now it's your turn! Practice the letter lines by outlining the letter on the right. Add dangles like the ones I drew (left), or create your own unique dangles!

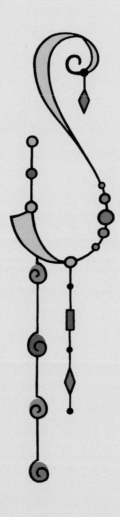

1. This is a very abstract representation of the lowercase "s."

2. Simple circle charms, like the ones added here, add points of interest.

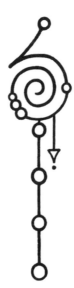

3. Now it's your turn! Practice the letter lines by outlining the letter on the right. Add dangles like the ones I drew (left), or create your own unique dangles!

1. The bubbled areas of this outline add depth to this simple drawing.

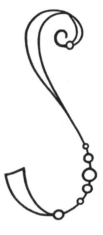

2. The addition of the circle charms makes the letter's outline more interesting.

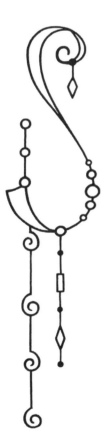

3. Now it's your turn! Practice the letter lines by outlining the letter on the right. Add dangles like the ones I drew (left), or create your own unique dangles!

1. For an exaggerated "t" shape, try wrapping the crossbar around the central column, as shown here.

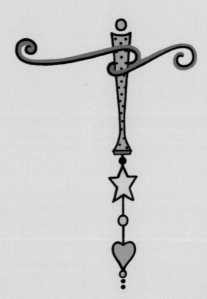

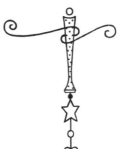

2. Be careful when adding elements like the circle atop the central bar—you don't want this letter to be confused with an "i."

3. Now it's your turn! Practice the letter lines by outlining the letter on the right. Add dangles like the ones I drew (left), or create your own unique dangles!

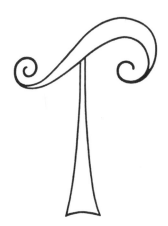

1. When making your flourish on the right side of the "T," be careful not to bring it too close to the vertical bar, or your letter may be mistaken for a "P."

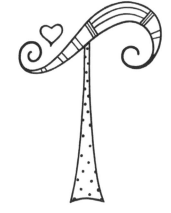

2. The freestanding heart charm on the top left provides a counterbalance to the thick swirl on the opposite side.

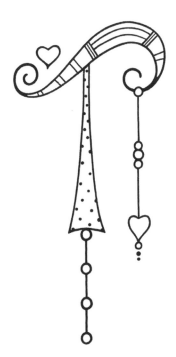

3. Now it's your turn! Practice the letter lines by outlining the letter on the right. Add dangles like the ones I drew (left), or create your own unique dangles!

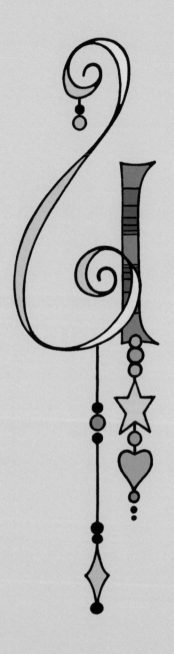

1. Experiment with new twists on traditional letter forms, like this fanciful lowercase "u." The exaggerated height difference between each side adds drama, and the angular edges and empty spaces will make it easy to add pattern and color.

2. The dot charms above and below the right column accentuate the serifs and provide a useful platform for connecting dangles.

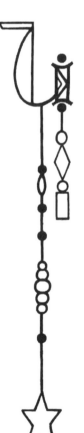

3. Now it's your turn! Practice the letter lines by outlining the letter on the right. Add dangles like the ones I drew (left), or create your own unique dangles!

1. Break this letter into pieces to make it easier to draw. First, draw the straight column on the right (which resembles the letter "I"), and then add the squiggle on the left (which resembles a backward "S").

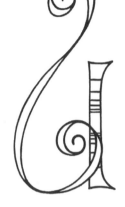

2. This letter is already very ornate, so a simple horizontal line pattern has plenty of impact. Note that the lines are mirrored top to bottom.

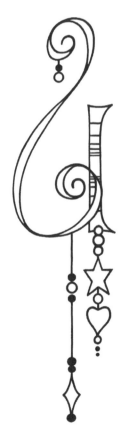

3. Now it's your turn! Practice the letter lines by outlining the letter on the right. Add dangles like the ones I drew (left), or create your own unique dangles!

1. This traditional outline replaces one serif with a playful swirl.

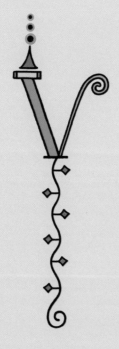

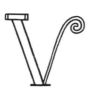

2. The addition of the two vertical lines in the straight serif will help you center any charms that you place above them.

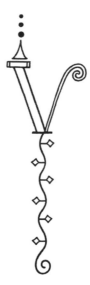

3. Now it's your turn! Practice the letter lines by outlining the letter on the right. Add dangles like the ones I drew (left), or create your own unique dangles!

1. Like with this "V," try combining very straight, angular shapes with contrasting curves of a different thickness.

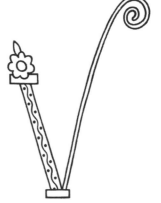

2. The wavy line and dot pattern creates movement in the boxier side of the "V."

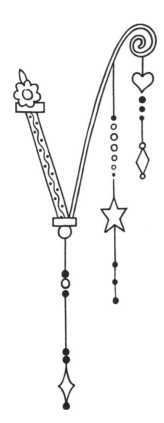

3. Now it's your turn! Practice the letter lines by outlining the letter on the right. Add dangles like the ones I drew (left), or create your own unique dangles!

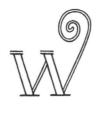

1. The outline of the "w" is a study in the contrasts between the sharp lines of the serifs and the spiraling swirl.

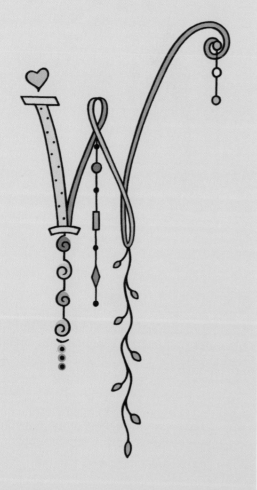

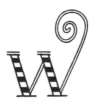

2. This horizontal black-and-white stripe pattern enhances the contrast.

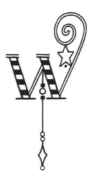

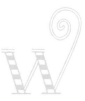

3. Now it's your turn! Practice the letter lines by outlining the letter on the right. Add dangles like the ones I drew (left), or create your own unique dangles!

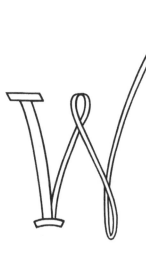

1. It is easiest to draw the curving line on the right side of the "W" using a pencil first. You can then work out how the curves will overlap.

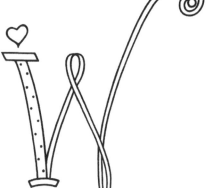

2. The heart balances the elaborate swirl on the opposite side of the letter and adds warmth.

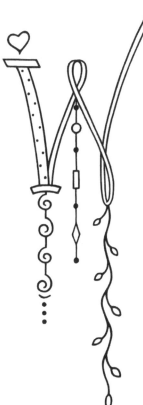

3. Now it's your turn! Practice the letter lines by outlining the letter on the right. Add dangles like the ones I drew (left), or create your own unique dangles!

1. This outline combines delicate swirls with elegant serifs—and provides plenty of space for your dangles.

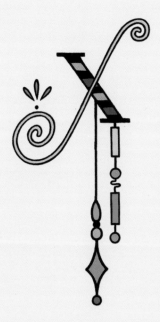

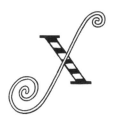

2. The graphic pattern reinforces the horizontal lines of the serifs.

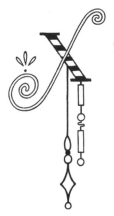

3. Now it's your turn! Practice the letter lines by outlining the letter on the right. Add dangles like the ones I drew (left), or create your own unique dangles!

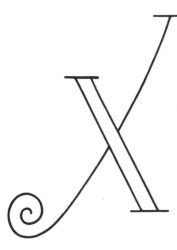

1. This is one of the easiest outlines to draw in the entire alphabet, so it's perfect for beginners.

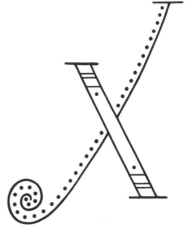

2. Use the dot pattern to unify the straight and curved elements of this outline.

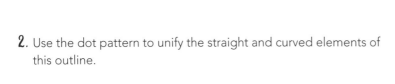

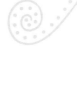

3. Now it's your turn! Practice the letter lines by outlining the letter on the right. Add dangles like the ones I drew (left), or create your own unique dangles!

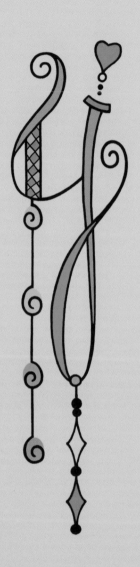

1. To make your letter more contemporary, vary the heights of the serifs so that they don't fall on the same linear plane.

2. The stripe patterned–area resembles a cat's tail.

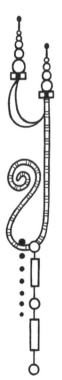

3. Now it's your turn! Practice the letter lines by outlining the letter on the right. Add dangles like the ones I drew (left), or create your own unique dangles!

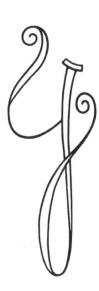

1. The absence of straight lines in the "Y" gives the letter a charming, whimsical vibe.

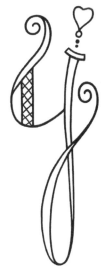

2. To balance the whimsical curved lines, try adding a bar with a crisscross pattern on the left side.

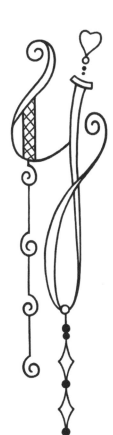

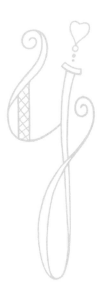

3. Now it's your turn! Practice the letter lines by outlining the letter on the right. Add dangles like the ones I drew (left), or create your own unique dangles!

1. This outline here is reminiscent of the cursive letter "z," but with an additional flourish.

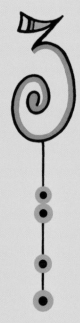

2. The addition of two simple vertical lines in the upper part of the letter adds visual interest to this piece.

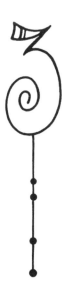

3. Now it's your turn! Practice the letter lines by outlining the letter on the right. Add dangles like the ones I drew (left), or create your own unique dangles!

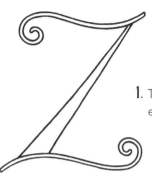

1. The "Z" is another fairly easy letter to draw, and the flourishes on both ends are natural spots for hanging your dangles.

2. The pattern plays with perspective, with the diagonal bar appearing to move farther away as the eye travels to the top.

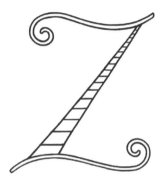

3. Now it's your turn! Practice the letter lines by outlining the letter on the right. Add dangles like the ones I drew (left), or create your own unique dangles!

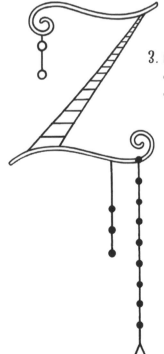

Dangle Words

*D*angle words are some of the most requested pieces on my website, *Olivia and Company* (oliviaandco.com). Part of the reason is because they are very challenging to make. I've included some of my most requested words here in this book for you to try your hand at drawing.

It may be difficult, at first, to progress from drawing solitary letters to words. Single letters are easier of course: there is no need to match letter styles or plan out a cohesive piece. Don't be discouraged if it takes a while to develop the skill to transition from letters to words. Once you feel fairly comfortable drawing individual letters, I recommend starting your first word. At first, you may find it easiest to try drawing each letter individually, perhaps on a separate piece of paper, and then bringing them together onto a final sheet.

Once you are comfortable and confident in your dangle art, you can progress to drawing a full word on a single sheet of paper. The letters should ideally have a uniformity of character and shape which is easier to accomplish when you draw everything on the same page.

One of the key shortcuts to remember when drawing dangle words is that using flourishes and patterns will help unify the word, making it more cohesive and easier to read, even when it's heavily adorned with charms. Take "Exquisite" below: The simple pattern of lines and dots that fills the letters repeats throughout the word. This helps the word stand out from the charms that decorate it and gives

the eye something to focus on. Also, the simple flourishes that accentuate the top left and bottom right of the word mimic the swirls on the "t," giving the word a unified feel because the flourishes are almost framing it.

Again, don't be discouraged if it takes a while to master the art of creating a dangle word. But once you do, you'll be able to create all sorts of wonderful projects: signs for a child's room using his or her name, hand-lettered invitations, personalized stationery, original artwork for framing and hanging, inspirational messages written entirely in dangle art, and lots more.

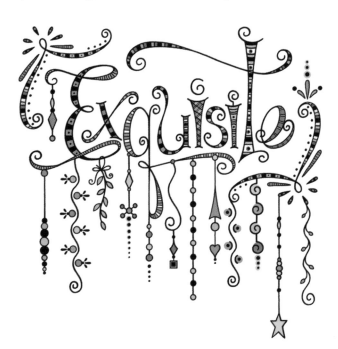

1. Swirl flourishes are a unifying characteristic throughout the word and help give the art consistency.

2. The simple patterns repeat many times throughout this word, creating a cohesive whole and making it easier to read the word out of context.

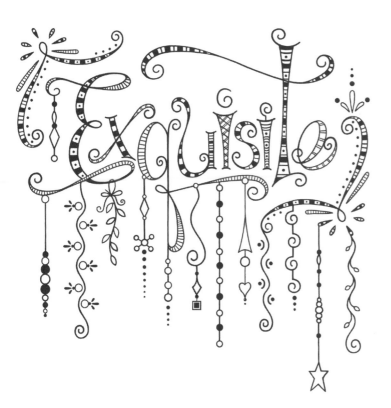

3. Although it might not look like it, the dangles in this piece are only on the "E," the "q," and the frame on the far right. They are not on every letter, but it still looks full and beautiful.

4. Now it's your turn! Practice the letter lines by outlining the word below. Add dangles like the ones I drew here (above), or create your own unique dangles!

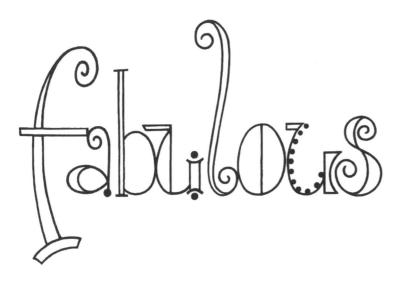

1. There is a bolder, more graphic feel with this dangle word, as you can tell from the dot pattern that is used consistently throughout the word.

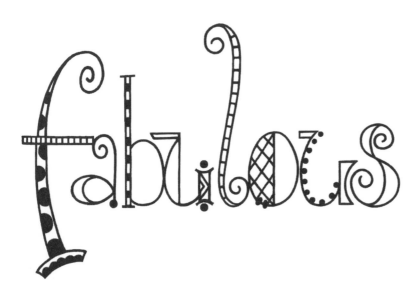

2. This word illustrates that you don't need to use the same pattern if your word is easily found amidst the art.

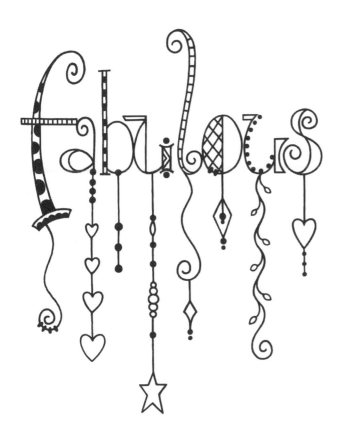

3. In this word, each letter has a charm. This keeps the word balanced and prevents any one letter from getting too crowded with hanging charms.

4. Now it's your turn! Practice the letter lines by outlining the word below. Add dangles like the ones I drew here (above), or create your own unique dangles!

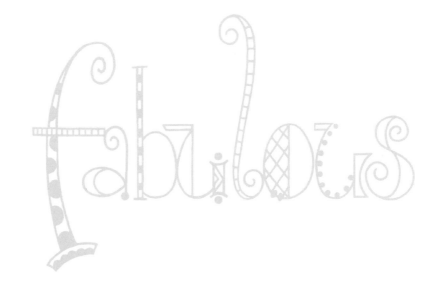

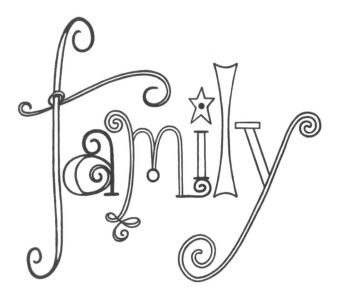

1. The star charm has the dual function of replacing the traditional dot in the "i" and offering a positive association with the overall message of the word.

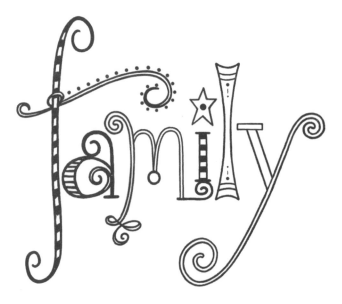

2. Though they are all different line weights, the horizontal patterns here will help break up large areas of color later.

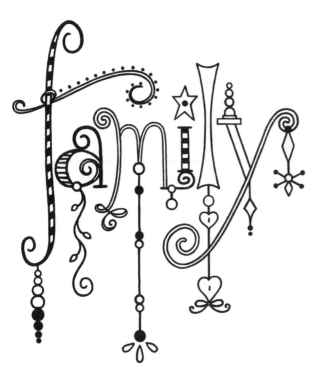

3. Notice that the dangle on the "l" goes behind the flourish of the "y." Use perspective to your advantage when you're organizing your drawing.

4. Now it's your turn! Practice the letter lines by outlining the word below. Add dangles like the ones I drew here (above), or create your own unique dangles!

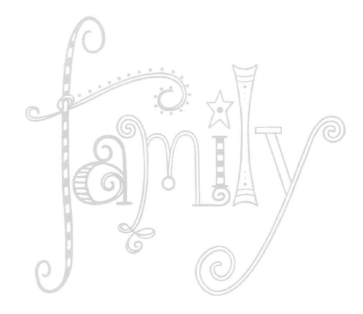

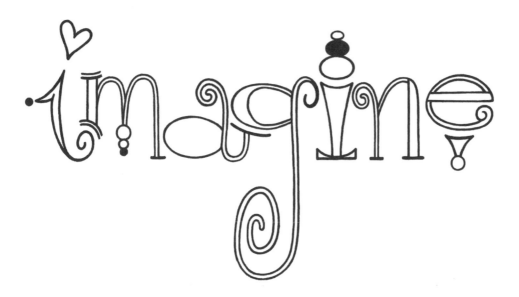

1. I chose a bubbly style for "imagine,"
 which carries a lot of energy with it.

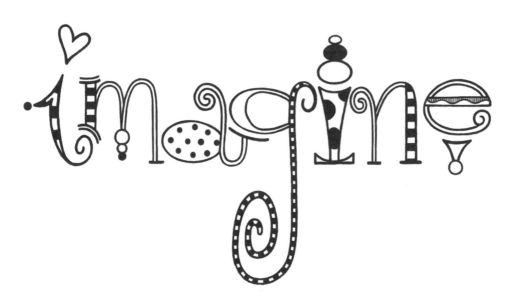

2. The dot patterns are ideal for when you
 need to break up open blocks of space.

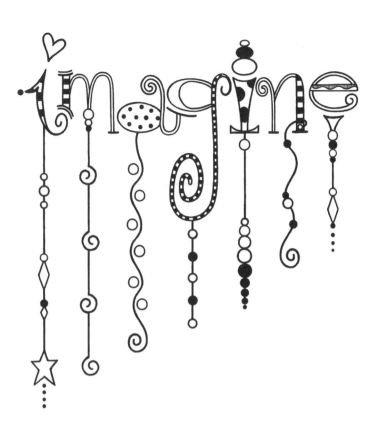

3. This word uses one charm per letter, and the lengths of the charms gradually decrease from left to right, creating an angular look to the word.

4. Now it's your turn! Practice the letter lines by outlining the word below. Add dangles like the ones I drew here (above), or create your own unique dangles!

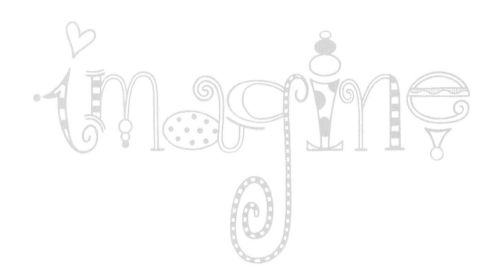

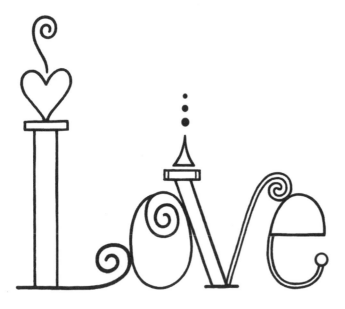

1. Choose charms that reinforce the message you want to deliver, like the heart I've selected at the beginning of this word.

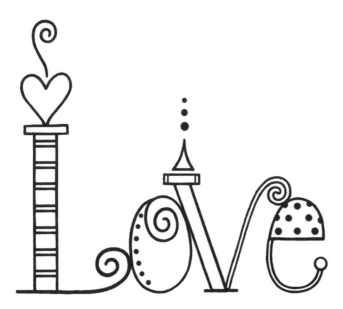

2. The understated patterns used here leave the emphasis on the word itself and the heart.

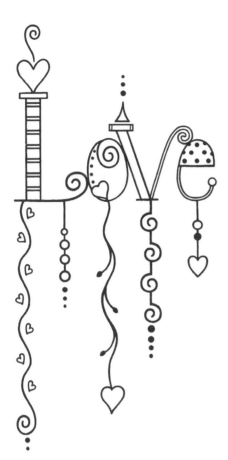

3. Try starting a dangle with a charm shape like the heart or the triangle that are on top of the letters!

4. Now it's your turn! Practice the letter lines by outlining the word below. Add dangles like the ones I drew here (above), or create your own unique dangles!

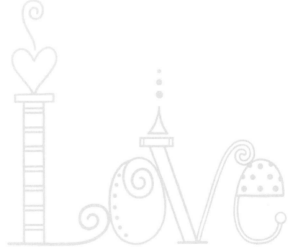

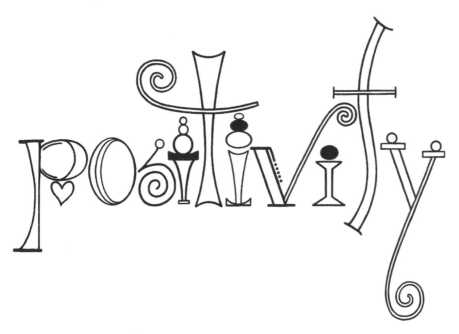

1. To reinforce the word "positivity," I've added circle charms on top of several letters in the piece that are "looking up."

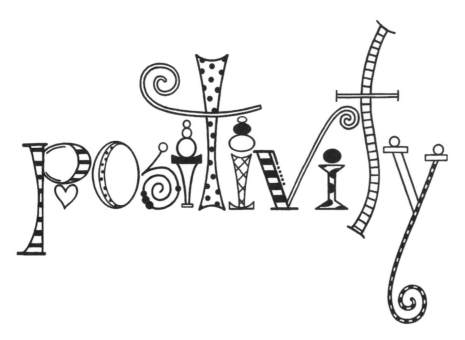

2. As you can see, I've used a mix of active, happy patterns to help flesh out this word.

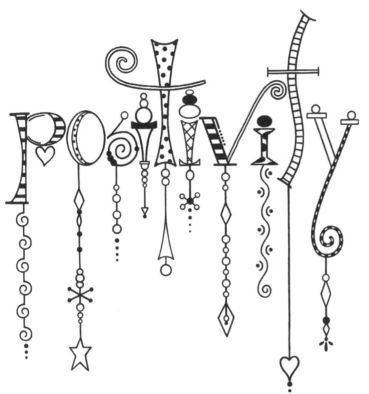

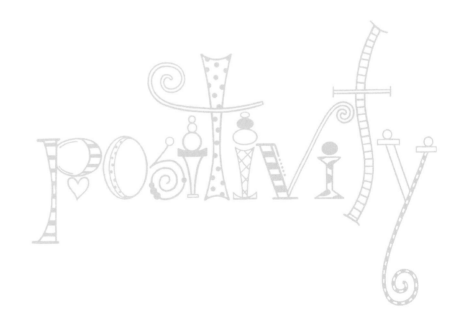

3. The dangles and charms along the bottom are also filled with energy and positivity!

4. Now it's your turn! Practice the letter lines by outlining the word below. Add dangles like the ones I drew here (above), or create your own unique dangles!

Dangle Shapes and Mandalas

\mathscr{J}ust as any letter can become a dangle letter, or any word can be adorned with dangling charms, you can make any shape playful and whimsical by adding patterns and charms to it. From stars and hearts to diamonds and swirls, transforming any shape into a dangle shape is easy. Start off with the shape like a star or heart first, keeping the original outline simple.

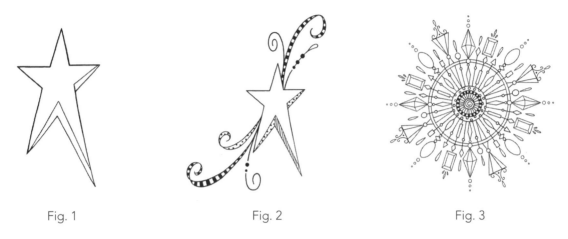

| Fig. 1 | Fig. 2 | Fig. 3 |

The second step, as with the letters and words, is to add a playful pattern inside the shape. Popular patterns include both random and deliberate dots, stripes, squiggles, and so on. More complex shapes may naturally require more colors or more detailed work.

Next, sketch your dangles. There are no rules for where you should place them or how they have to behave or appear. They can hang down from your shape or flow upward; they can be long or short; and you can add as many charms as you feel are appropriate for the piece. In Fig. 2, notice that squiggly lines have been drawn behind the star as a dangle flourish rather than a traditional hanging dangle.

Next comes the fun part! Finish off your pieces by coloring in your dangle shapes. Please see page 9 for examples of some of the tools I use to color, or just choose your favorite coloring tools, whether they are pencils, pens, or markers.

The final pieces of art in this chapter—mandalas—are also the most complicated. Mandalas are graphic, symbolic patterns, usually in the shape of a circle, that aid in meditation (See Fig. 3). Drawing and coloring them are excellent ways to soothe your mind after a long day at school or at work. Drawing mandalas, however, can be a challenge for even an experienced artist.

The most difficult part of drawing a mandala is making sure that the spacing is correct. While they don't need to be symmetrical, you want the inside of the mandala to have a certain order to it. As with other charming creations, once you're satisfied with the placement of your lines, feel free to go over them with a pen before coloring them in.

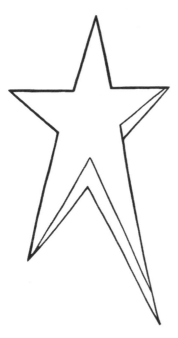

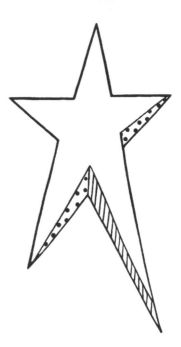

1. Start by drawing a simple star shape. Then add a few extra lines which add a hint of three-dimensionality to it, as shown here.

2. For a different effect, I added my patterns to the 3-D portions of the star instead of the main shape. It really lifts the shape and adds even more dimension.

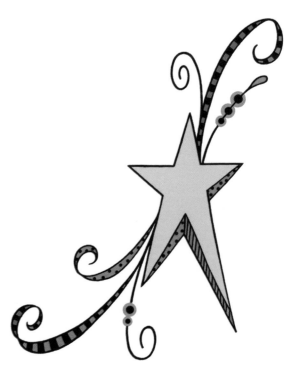

3. The dangle flourishes behind the star add a hint of playful activity and movement to it.

4. The 3-D pattern is colored in shades of red and orange, creating a colorful shadow effect.

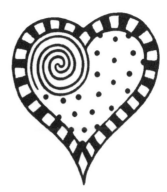

1. This shape begins with a really simple heart outline.

2. I've combined three simple patterns within this heart: a striped border drawn within the heart, a spiral in the upper-left quadrant, and polka dots in the remainder of the shape.

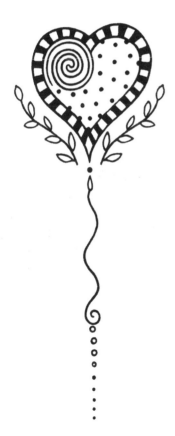

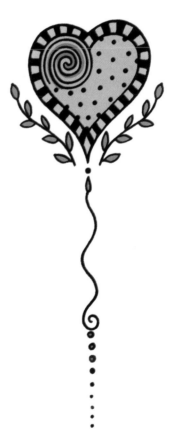

3. The vines on either side of the heart lend an organic vibe to this drawing.

4. The four colors I used in this piece were intended to evoke the warm tones of spring.

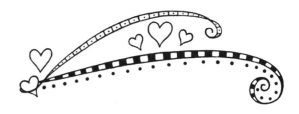

1. To draw this, start with the basic heart shape on the left and then add the looping ribbon flourishes.

2. Add a graphic pattern to the looping ribbons and hearts in the center to increase the shape's visual interest.

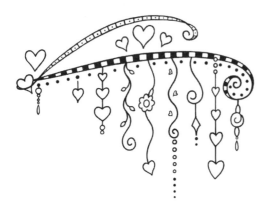

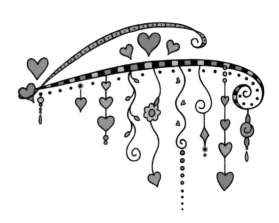

3. Add heart dangles to the lower ribbon if you want to reinforce the original love theme.

4. You'll notice that several of the dangles and charms aren't actually touching the art here. Tucking charms into the curve of ribbons or hanging dangles from a dot pattern can work if they are arranged carefully.

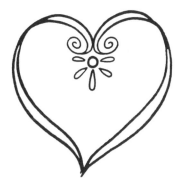

1. As with the heart on page 81, this one also begins with a simple outline.

2. Here, simply go over the outline a second time to add depth, and then add some shapes in the center, like circles and teardrops.

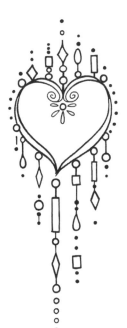

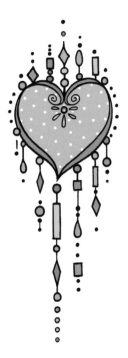

3. The dangles here are just simple strands of geometric shapes, including circles, diamonds, and rectangles, but they create an elaborate look because they are both flowing upward and hanging down.

4. The white polka dots, which were formed by adding color around them, provide a softening effect.

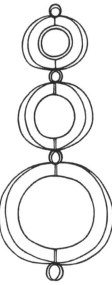

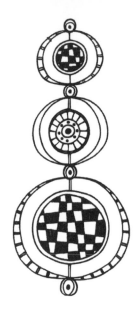

1. Break down this piece into steps, drawing each circle individually.

2. Add patterns to the inner circles as desired.

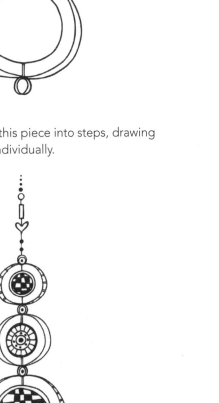

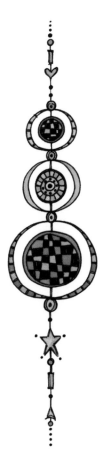

3. The dangles we've added to the top and bottom of this drawing appear as a single dangle thread running through the circles.

4. Leaving the areas without pattern white gives the impression that each circle could spin independently, like a mobile.

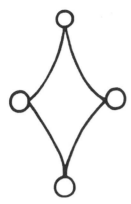

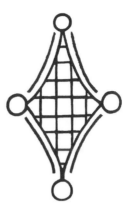

1. Begin with a simple outline; this is a diamond with some circles at each of the points.

2. This simple crosshatch pattern adds a grid-like element against the curves.

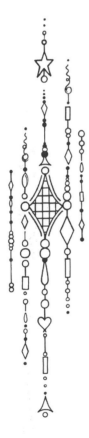

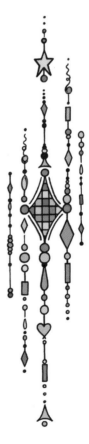

3. The simple diamond is transformed here by the addition of dangles and charms above, below, and on the sides. In this case, the image is reminiscent of a crystal chandelier.

4. The coloring of this piece is a bit more complex, as I've added a different color to each line and charm. You can see how the color variety makes this such a charming, vibrant piece of art!

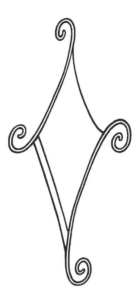

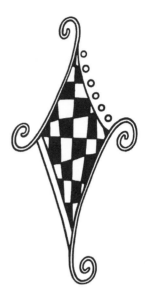

1. This stylized diamond has some depth and elegance because of the additional swirls and flourishes.

2. The intentionally lopsided checkerboard pattern adds an element of playfulness to the diamond's interior.

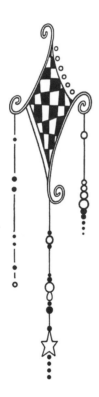

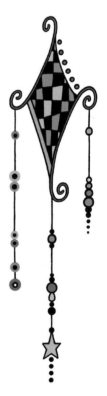

3. These dangling circle and dot charms add a strong but elegant contrast to the black squares within the diamond.

4. Try using color to connect two distinct charms, as I've done with the circle and dot charms on the left dangle.

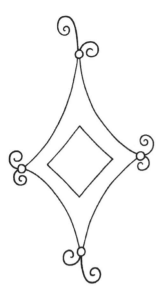

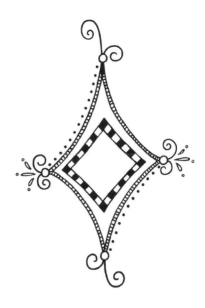

1. This is simply a diamond within a more elaborate diamond.

2. Bulk up the inner and outer diamonds with a simple graphic pattern. The flourishes on either side resemble flowers opening.

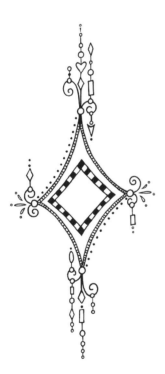

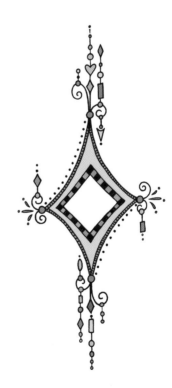

3. The charms in this drawing are defying gravity in an artful way. Use your imagination and draw them in whatever way you wish.

4. Feel free to add a letter in the white space if you're designing this piece for someone in particular.

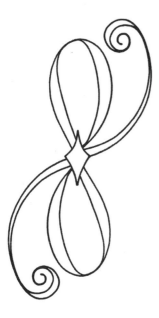

1. Break this bow apart to make it easier to draw. Begin with the small diamond in the center. Follow that with the basic figure-eight shape, and then add the bow flourishes.

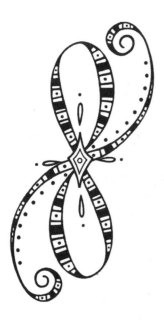

2. Add a dot pattern that follows the curve of the swirl and accentuates the flourish.

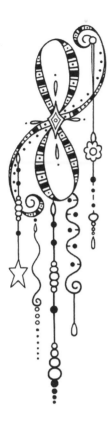

3. The stylized swirl appears to be holding dangles wherever it can in this piece. Each dangle is a different length and contains different charms, which add a lot of glamor.

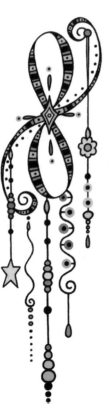

4. The colors of the swirl make it a vibrant centerpiece among the bright charms.

1. Swirls like this ribbon can be added to any drawing to add a nice dramatic flair.

2. Add circular charms at various points on this ribbon; it will make it easier to add dangles in the next step.

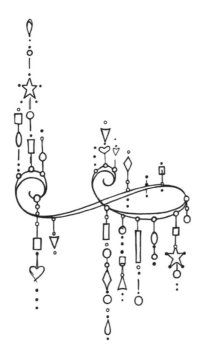

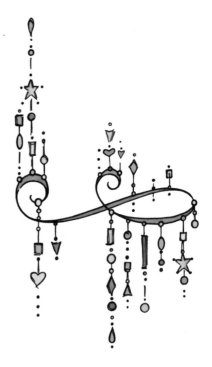

3. Attach dangles to the circular charms as well as any other points on the ribbon. You can see the dangles I've included here go up and down along the swirls.

4. Making the swirl a solid pink helps to unify the drawing as well as allow the dangle threads to stand out as individual strands.

1. These swirls are reminiscent of eyelashes. To make it easier to draw, begin with the circle at the right and then add each set of lines until you are satisfied.

2. The added line pattern repeats in each flourish except for the smallest one at the top right. The pattern is different in each strand, which adds visual interest and dimension.

3. These charms play with perspective—some appear to fall in front of the swirls, while others appear to fall behind them.

4. The color palette here brings a lot of energy to the final artwork.

DRAWING A ROSE MANDALA

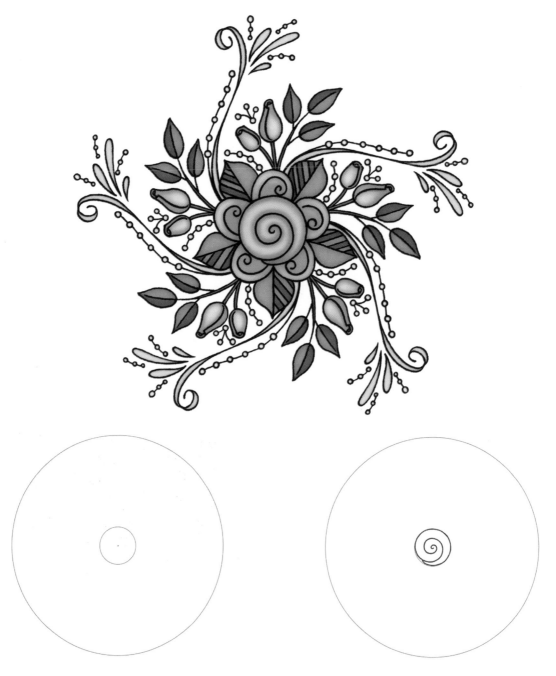

1. Using a pencil and a light touch, begin by drawing a dot in the center of the paper, and then draw both a 1-inch (2.5 cm) and a 6-inch (15 cm) circle around it. Keep these as your guidelines for drawing any mandala in this book.

2. Within the inner circle, draw a spiral that is approximately the same size as that circle. On the last loop around, close the spiral by drawing it into the last loop. This is the beginning of the inner rose.

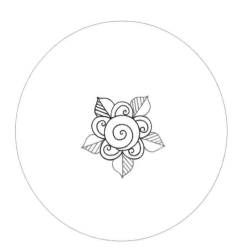

3. Around the rose, draw five semicircles with their edges touching. These are the rose's petals. Within each petal, draw a single swirl.

4. Between each of the rose petals, add a leaf; you should have five of them. Divide each leaf in half by drawing a line down the middle of each. To add definition to the leaves, draw diagonal lines on one side of each leaf, drawing these diagonal lines on the same side of each leaf to maintain balance.

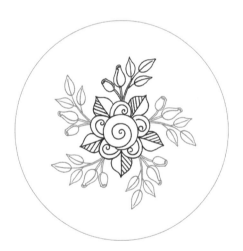

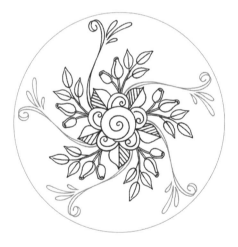

5. On top of each of the existing rose petals, draw three stems of varying lengths; one should lean to the left, one should be straight, and one should lean toward the right. On the left and center stems, draw a simple rosebud. On the right stem draw three simple leaves with lines down their middles. You should have five of these when you're done.

6. Along the left sides of the leaves, draw ribbons that veer up toward the outside guide circle and curve right over the rosebuds you drew in the last step. End each ribbon with an elegant swirl. For added decoration, draw three loops resembling paisleys to the right of each ribbon, extending toward the outer guide circle. You should have five sets of these ribbons and loops.

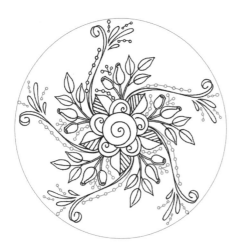

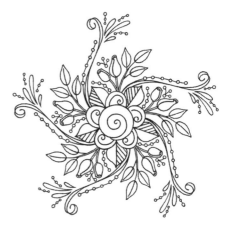

7. To further decorate the mandala, soften the ribbons you drew in the previous step with chains of tiny circles. The illustration suggests where to place them, but feel free to experiment with your own placement.

8. Trace over the pencil lines with a finepoint pen or marker. Erase all of the pencil lines, including any remaining guidelines that you have. You have completed the outline of a rose mandala!

DRAWING AN EARTH MANDALA

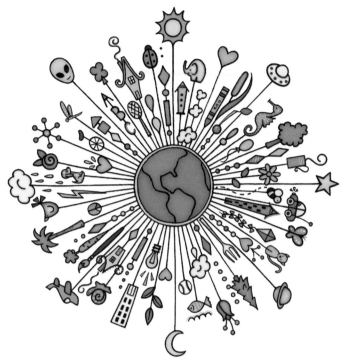

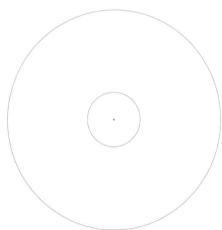

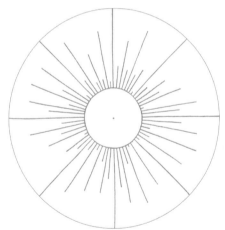

1. Using a pencil and a light touch, begin by drawing a dot in the center of the paper, and then draw both a 1-inch (2.5 cm) and a 6-inch (15 cm) circle around it. Keep these as your guidelines for drawing any mandala.

2. Draw eight evenly spaced lines extending from the inner circle to the outer circle. You can use a protractor to make sure the lines are evenly spaced; alternatively, divide the space into quarters and then divide each quarter in half. Between each of the eight lines, draw seven evenly spaced lines of varied lengths. None of these lines should be as long as the eight guidelines.

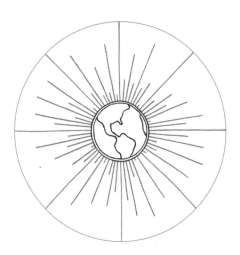

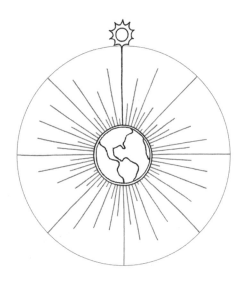

3. Within the inner circle, draw the Earth. You can reference a globe for this so that you can accurately draw landmasses and oceans. Pick a spot on the Earth that really means something to you. For example, if you love Italy, center the globe on Italy.

4. Beginning with the guideline at the center top of the image, draw charms that you associate with the Earth, like the sun. I like to position these on the ends of the major guidelines, but outside of the circle. This establishes boundaries for the mandala and helps find the outer edge once you erase the guidelines.

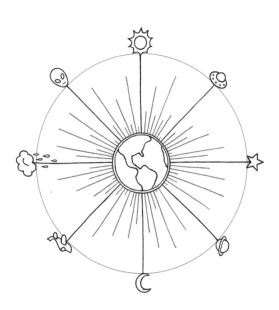

5. Continue drawing images you associate with the Earth on the major guidelines. You'll see that I added an alien, a storm cloud, the moon, a star, an airplane, a UFO, and a planet. All of the things I drew on the major lines are related to the sky and space.

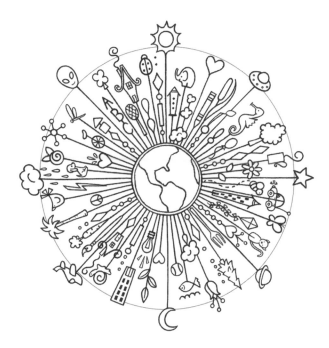

6. At the end of each smaller line, I drew more charms that related to the Earth. While my major lines had charms that were associated with space, within the outer circle I drew things that were found on Earth. Remember to draw wider charms before thinner ones in order to avoid overlap in these tight spaces. You may also want to draw your wider items at the end of the lines so that you have more room.

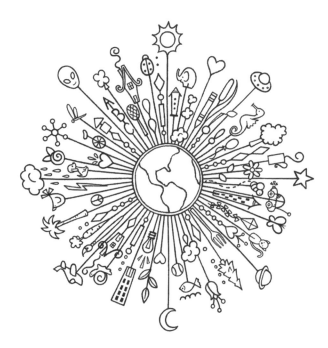

7. Trace over the pencil lines with a finepoint pen or marker. Erase all of the pencil lines, including any remaining guidelines that you have. You have completed the outline of an Earth mandala!

FLOWER MANDALA INSPIRATION

Use the same guidelines to draw this mandala as you did for step 1 of the rose mandala on page 92. This one, unlike the rose mandala, has six segments, so budget your space inside differently.

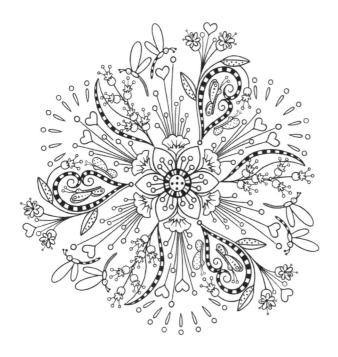

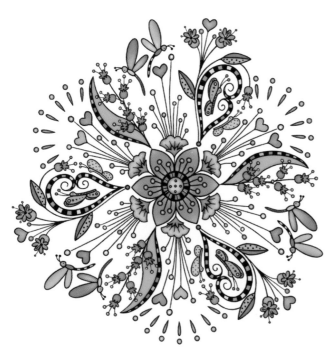

GEMSTONE MANDALA INSPIRATION

This mandala, unlike all of the others, repeats in quadrants. You can fold it in half along any of the outside charms for an almost perfect mirror image.

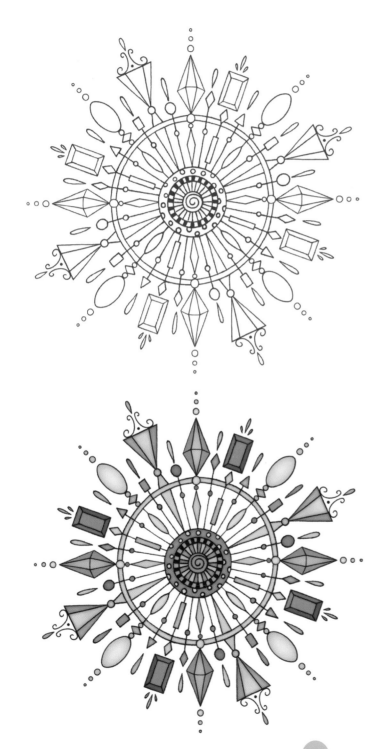

Everyday Dangles

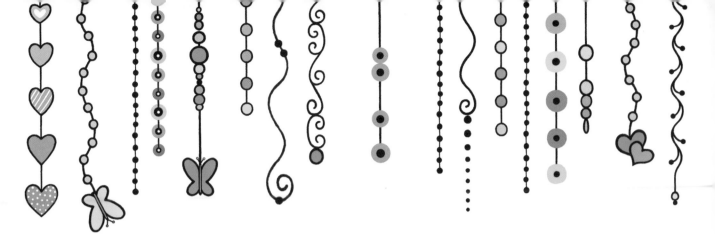

ow that you have mastered drawing charming letters, words, and shapes, let's try to put it all together. The dangles in this chapter vary from animals and plants to everyday household objects. They combine various shapes, allowing you to apply the skills you have learned drawing basic dangle shapes. Charming butterflies, beautiful hummingbirds, weeping trees, and elaborate representations of weather are all displayed as inspirational artwork.

After the natural subjects, we'll finish with household objects. These include beautiful candles and candlesticks and elaborate dream catchers, the latter of which combine words and shapes in beautiful and inspirational ways.

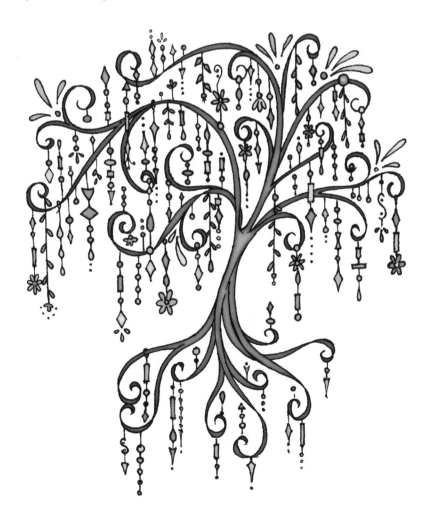

1. I playfully call this piece *Moon Light* because it is literally a moon adorned with different lights, from pendant lights to sconces to desk lamps—all in dangle fashion, of course. Feel free to draw your own *Moon Light* using this piece as inspiration. Or simply color with the palette of your choosing.

2. I specifically selected cool and calm colors for this piece, like blues and purples, since the moon is associated with sleep and nighttime.

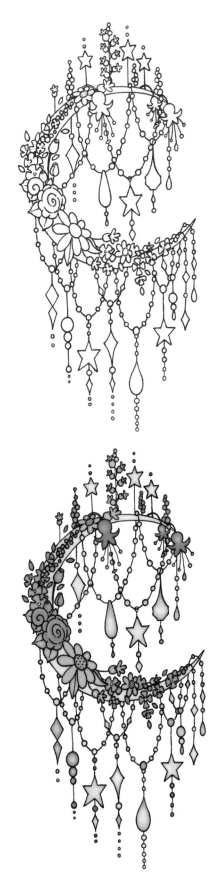

1. This heavily detailed drawing is so ornate that it might be difficult to see the moon at first glance, but you can make it more obvious with your color selection. The charm threads are laid heavily on so you can see the limitless possibilities of dangles. In your own creations you can add as many or as few as you like.

2. When colored, the moon is easier to see because it is a shade of yellow. The ornamentation is filled in with different colors and really stands out in the elaborate drawing.

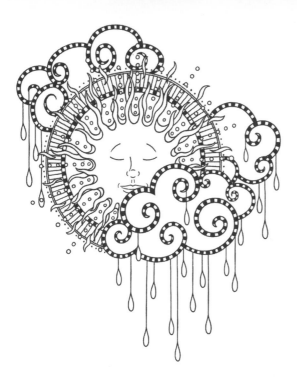

1. I call this piece *Afternoon Shower* because it combines the sleeping sun with the clouds of a rainstorm. The stylized pattern lines of the clouds really stand out against the thin lines of the sun's rays. Raindrops, too, are natural dangles, and they can be used successfully in your dangle art.

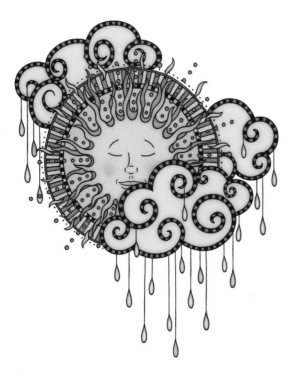

2. I went with the traditional colors associated with the sun and rain in this drawing: blue and orange, complementary colors that create the peaceful tableau of the afternoon sun shower.

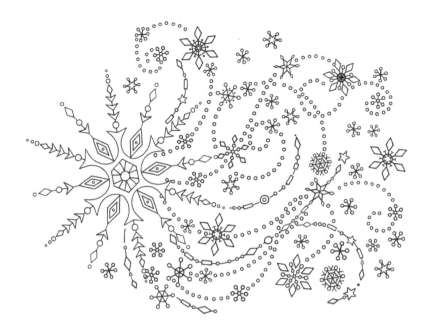

1. This elaborately drawn scene of falling snowflakes illustrates the movement and beauty of a snowstorm, with the circular dangles illustrating the motion of the wind and the individual snowflakes following its course.

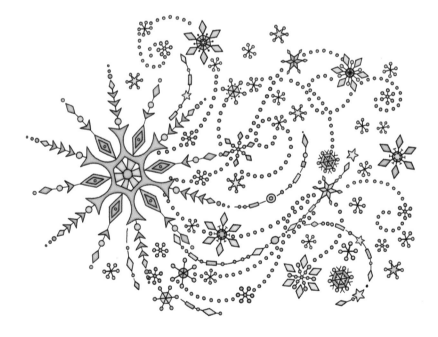

2. Try muted shades of cool colors, like blue and purple, to reinforce winter and snow. These colors coordinate nicely with the yellow diamonds and stars that can be found in the image.

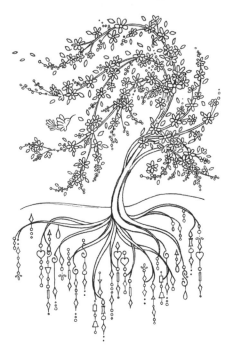

1. This beautiful cherry blossom tree exemplifies spring. The detailed leaves and flowers are drawn in detail, but the roots of the tree are more fantastical, growing in loops and curls, with many dangles and charms below ground.

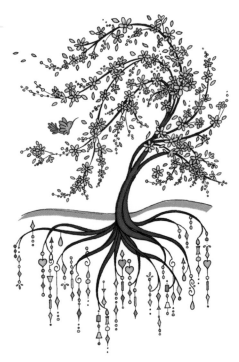

2. When colored, the blue bird appears to be arriving at the cherry blossom tree, heralding the arrival of spring. You can create dangles out of almost anything, including the incredible roots of this tree.

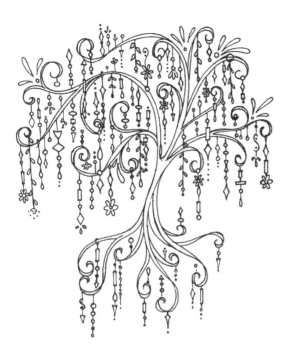

1. The willow tree contrasts with the cherry blossom tree on the facing page because it is obviously more fantastical, with charming dangles replacing the branches and leaves above ground as well as the roots below.

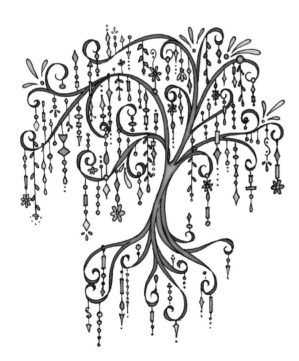

2. By coloring the tree in traditional shades of brown, the dangles remain the centerpiece of this image.

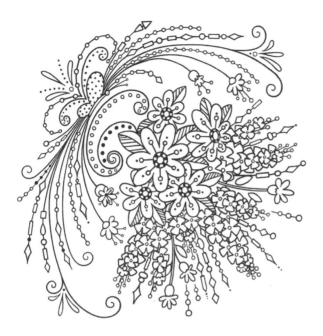

1. In black and white, the butterfly can be difficult to see, finding its natural camouflage against the flowers.

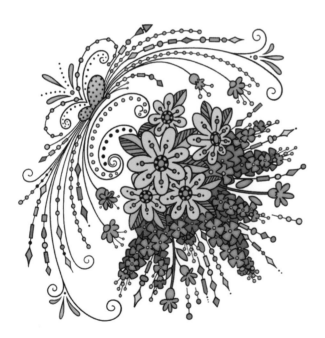

2. When color is added to this drawing, the butterfly in the top-left corner can easily be spotted. While still very abstract, the chosen colors complement each other in this magnificent nature scene.

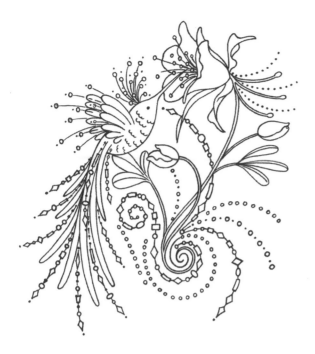

1. This hummingbird extracting pollen from a flower is almost entirely constructed with swirling lines and charms. The hummingbird's tail is encrusted with geometric gems, and circular charms and swirls dominate the rest of the drawing.

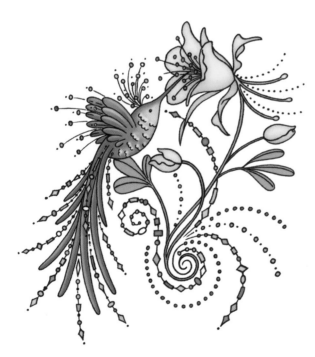

2. Here, the hummingbird, flower, leaves, and stem mostly consist of one main color each, so it is easy for the viewer to focus on the scene. The rainbow-colored charms are secondary and complement, rather than dominate, the serene image.

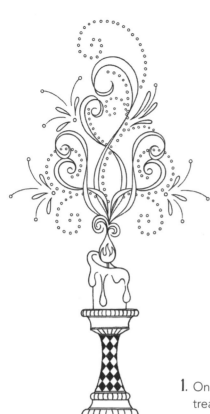

1. On this page and opposite, you can see the same candles with different treatments. In this drawing, the focus is clearly on the flame and the swirling lines coming off of it like fireworks.

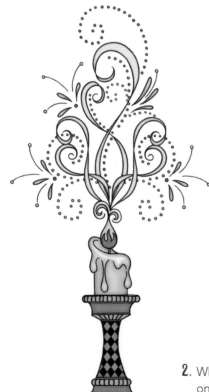

2. When colored, the focus of this image remains on the flame, which is the only warm color in the drawing, and the fantastical lines above it.

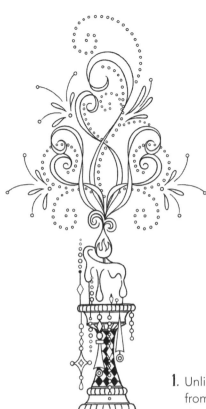

1. Unlike the image on the facing page, this image has charms dangling from the candlestick. The eye is thus brought down below the flame, drawing attention to the entire image.

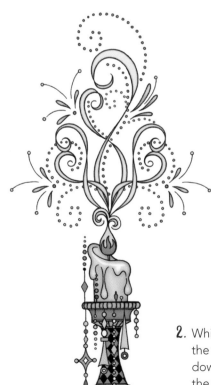

2. While this is almost identically colored to the image on the facing page, the focus here is on the entire image because the charms draw the eye downward. The flame itself is no longer the only warm color among all of the cool colors because the artist has also colored some of the charms in shades of yellow and orange.

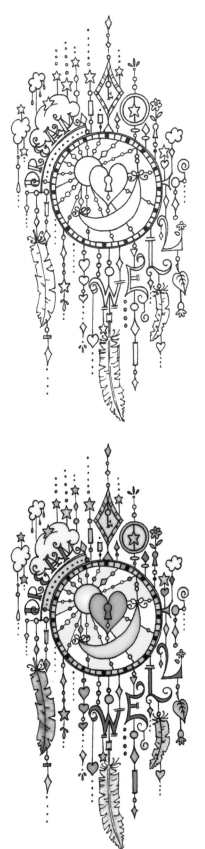

1. This dream catcher is a dramatically detailed representation of something you can create when you combine charming words and shapes. On the top left, you can see "DREAM" written among the charms. This is mirrored by "WELL" on the bottom right. Characteristic of most dream catchers, this one has traditional elements, like feathers, but it also displays some nontraditional elements, like a keyhole in the center where there is normally some kind of bead or stone.

2. Coloring this piece allows you to decide what areas to place emphasis on. By coloring the words in one shade of blue, they are unified and easily distinguishable. This piece of artwork would be at home in anybody's bedroom.

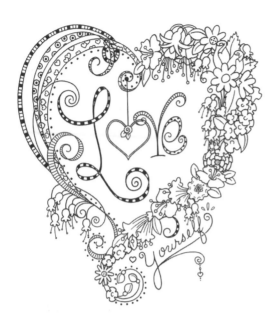

1. This ornate heart is constructed out of pattern lines on the left and flowers and similar ornamentation on the right. From the midpoint of the heart, I have hung the word "love," using a heart as the "o." At the bottom right of the heart, I have placed "yourself" in simple cursive writing.

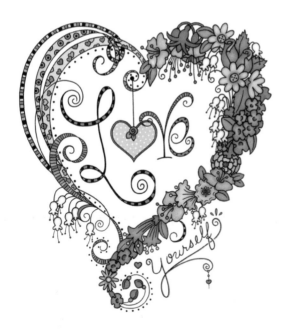

2. The heart makes an elaborate work of art when colored. Everything, with the exception of the word "yourself," is connected in the image.

Charming Projects

ow that you can combine letters into words, shapes into drawings, and all of them together, there is even more you can do with dangles and charms. From simple lettering to stationery, invitations, and anything else you can think of, dangles can help you make messages more fun and attractive.

For these projects, I suggest doing a rough sketch of your idea on scrap paper first. Once you are happy with your design, transfer it to thicker cardstock so that your creations can last longer and stand up to everything the world throws at them.

Two especially fun projects that anybody can do are gift tags and bookmarks—everybody needs to wrap gifts at some point and most people like to read. These charming projects add some fun to the process!

BOOKMARKS

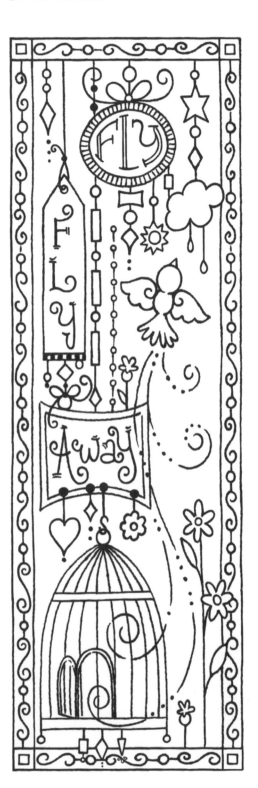

When you're drawing a dangle bookmark, begin by outlining the size and shape of the bookmark. Using a pencil and a ruler to keep the lines straight, draw a simple outline. Add a border with a pattern that is as simple or as complex as you like. Then, begin to fill the space inside of the border. Here, I have combined the words "Fly Away" with a bird escaping its cage, using the metaphor of reading as a way to escape the monotony of daily life.

When you are satisfied with the drawing you have created, go over it with a finepoint pen or marker to highlight all of the lines. Then erase any pencil guidelines so that you have a clean slate for coloring.

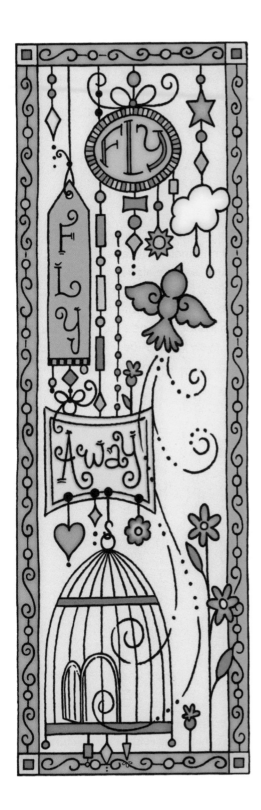

Now that the image is ready to be colored, it might be a good time to make a scan using your computer. Doing this saves the drawing, in case you color something incorrectly and need to start over. Use vibrant colors for areas you want to highlight and muted colors for areas that should fade into the background.

Once you're satisfied, cut the bookmark out, and it's ready for immediate use!

GIFT TAGS

To draw a gift tag, begin by outlining the size and shape that you want. Take into account such things as the length of the name that you need to fit and the size of the artwork that you are going to decorate the tag with. Using a pencil and a ruler to keep the lines straight, draw a simple outline. Remember to add a circle at the top so that you can punch a hole and thread ribbon through it. Now you can begin to sketch your image. Perhaps it has presents with elaborately charmed bows, or maybe you include flowers with charms and swirls.

When you are satisfied with your sketch, go over it with a finepoint pen or marker to highlight all of the lines. Then erase any pencil guidelines, making sure you leave the circle for the hole at the top.

If you think you may reuse the gift-tag design, consider scanning it into your computer so that it can be saved for later use. It's probably easier to print a new one that you can color than to start completely from scratch!

Now that you have a clean gift tag, add color. Make the background light enough that everyone can read the names in the "TO:" and "FROM:" fields. Apart from that, have fun making the tag as eye-catching as possible. Whoever receives the gift is sure to enjoy the thought and time you put into it.

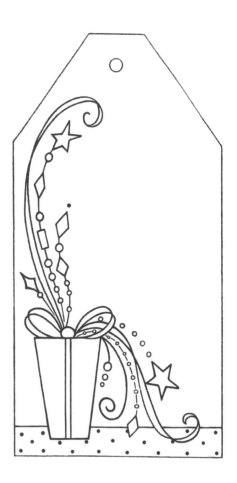 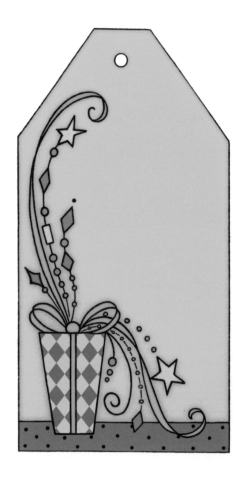

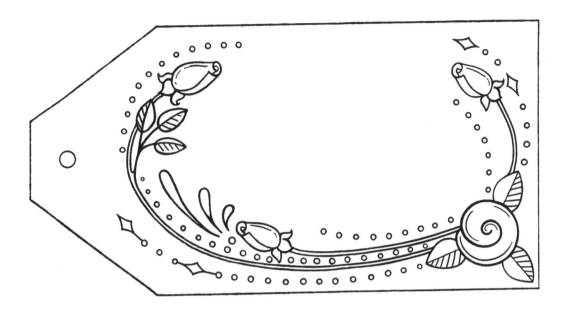

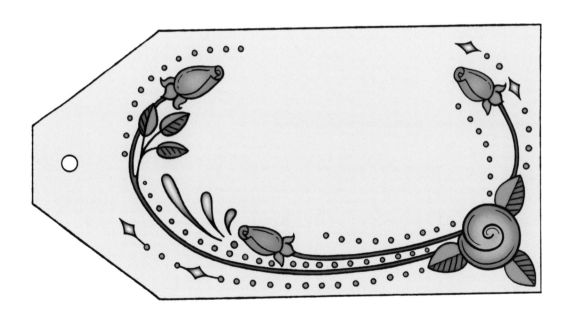

CHAPTER 6

Charm

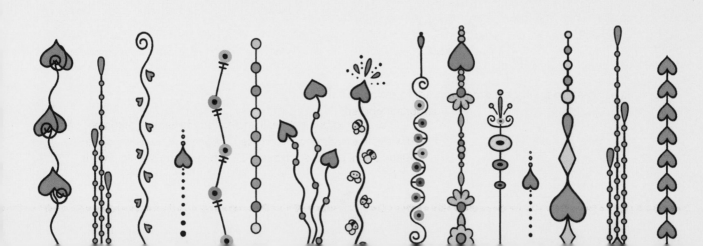

Directory

GEOMETRIC CHARMS

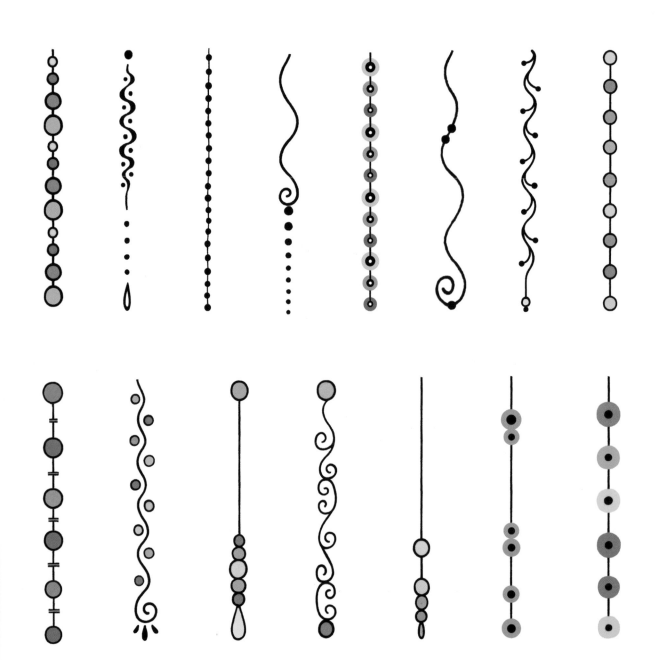

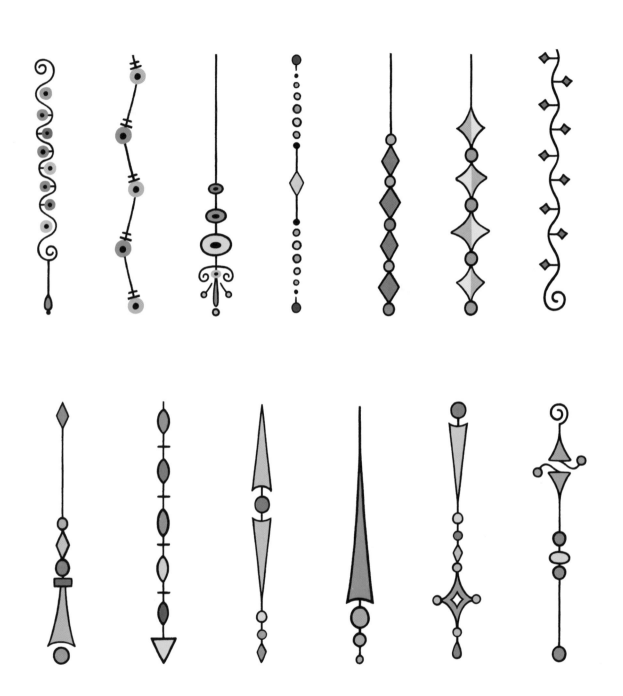

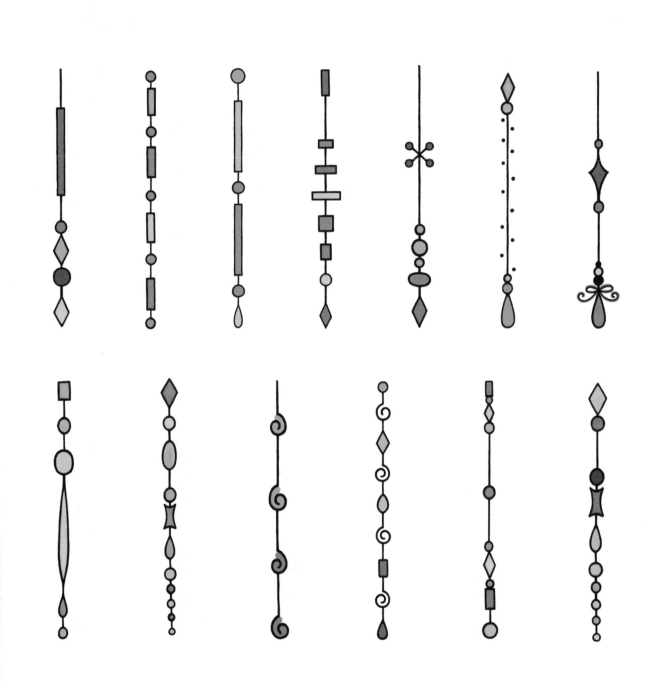

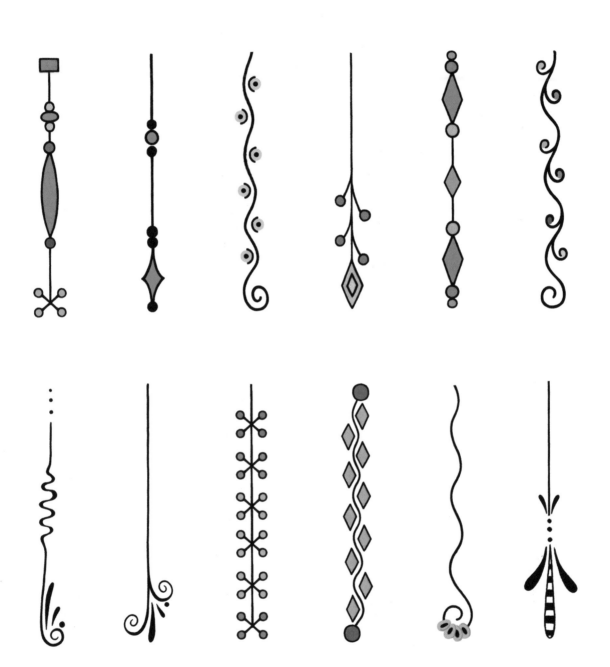

ORGANIC CHARMS

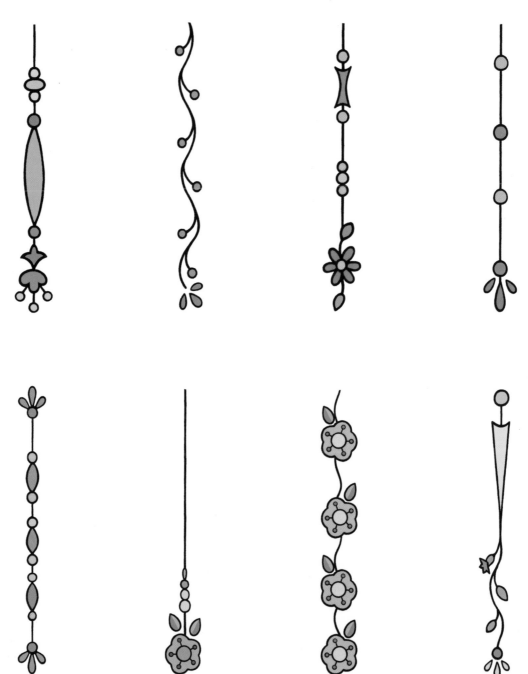

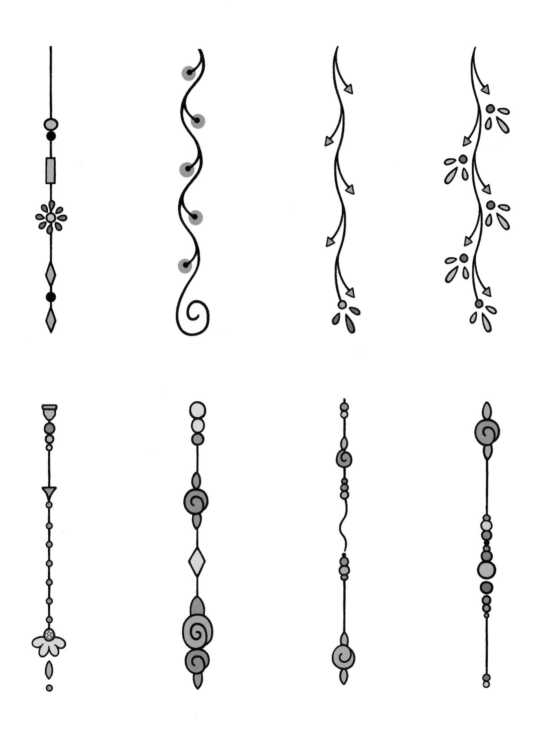

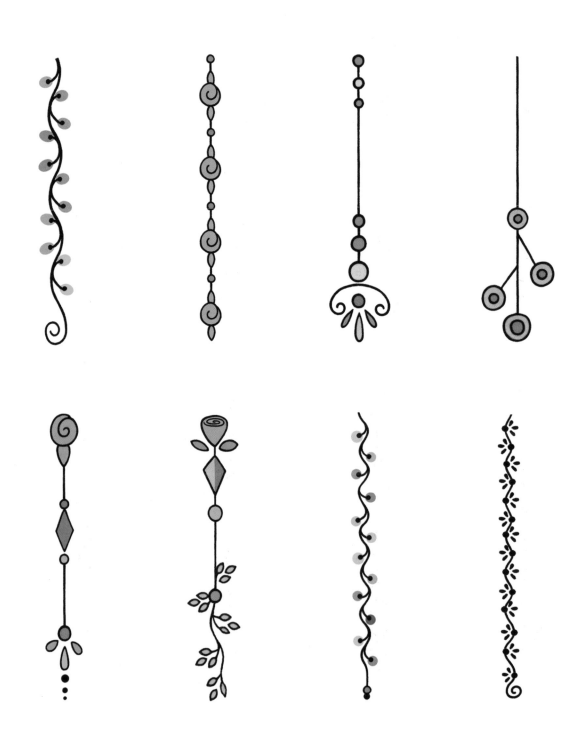

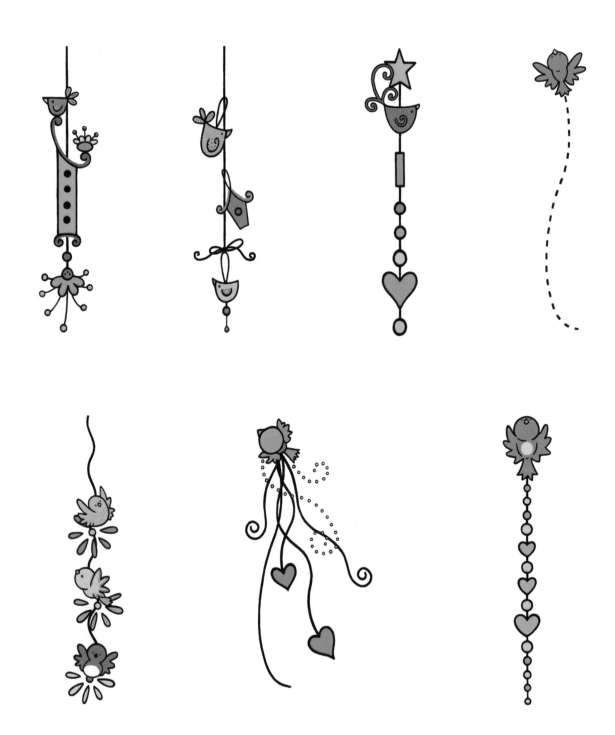

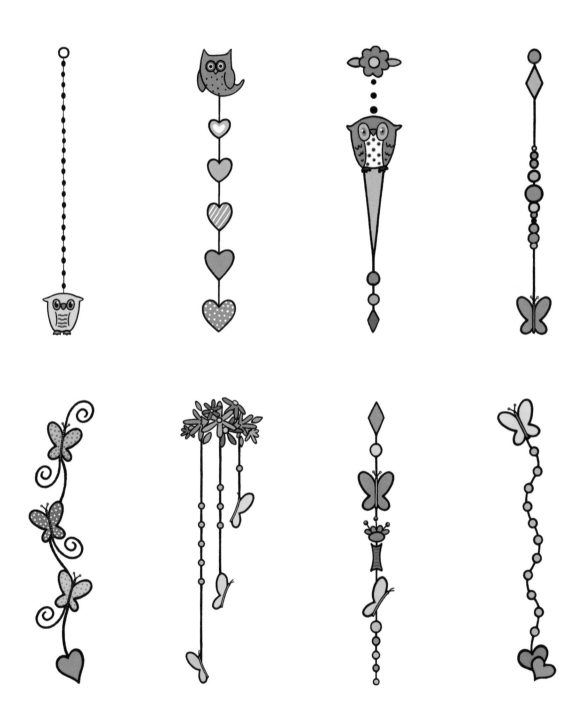

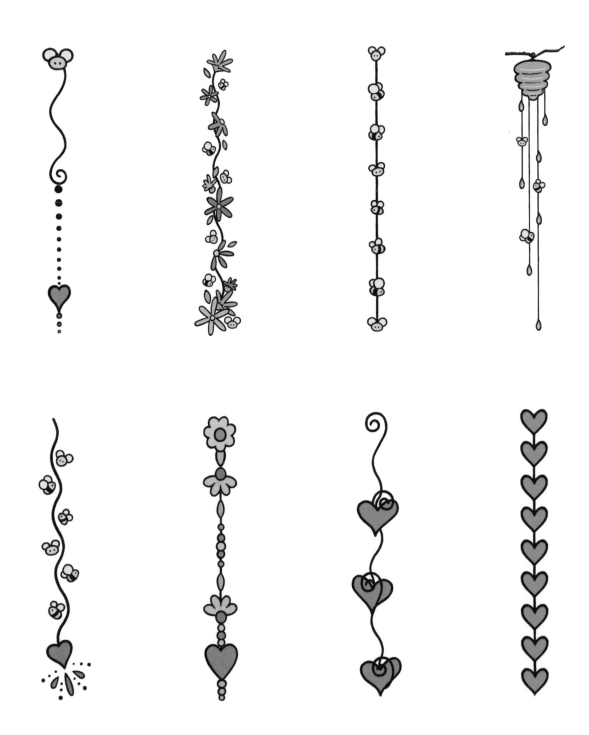

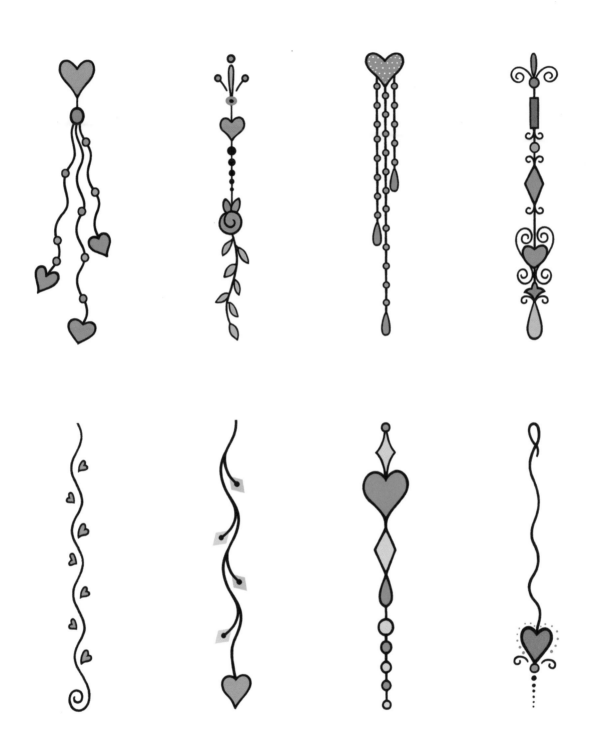

CHAPTER 7

Color Gallery:

Letters and Words

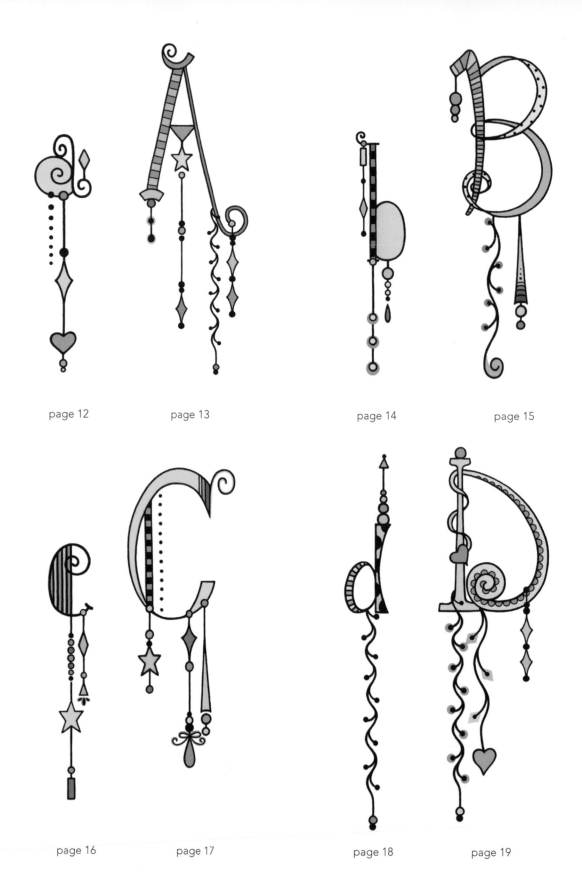

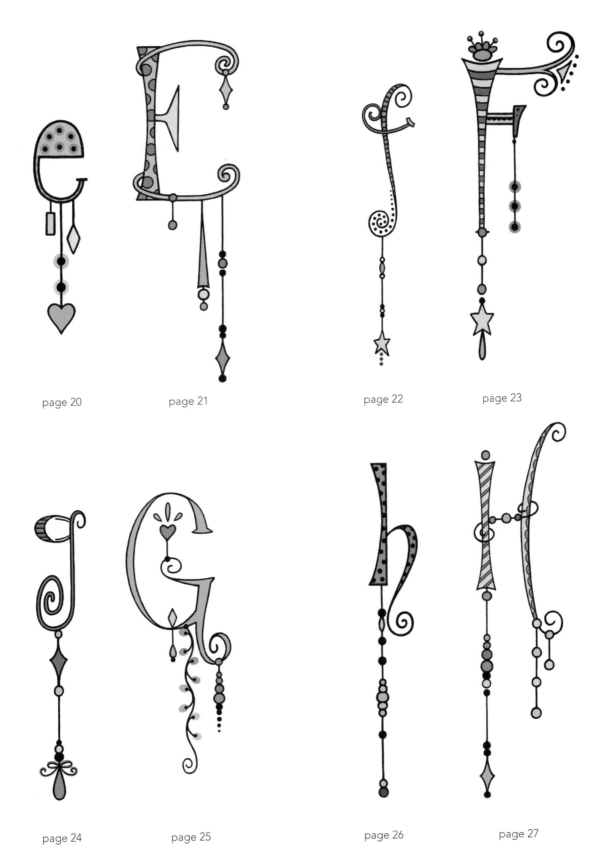

page 20 page 21 page 22 page 23

page 24 page 25 page 26 page 27

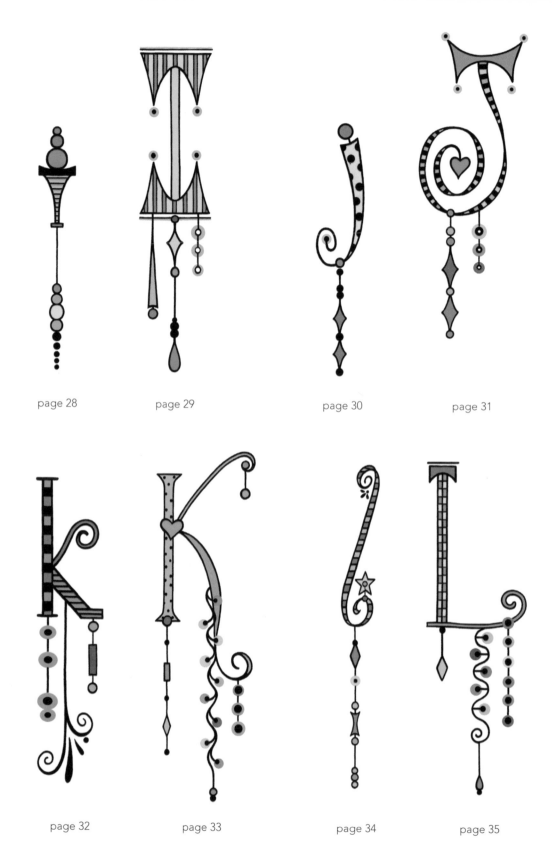

page 28 page 29 page 30 page 31

page 32 page 33 page 34 page 35

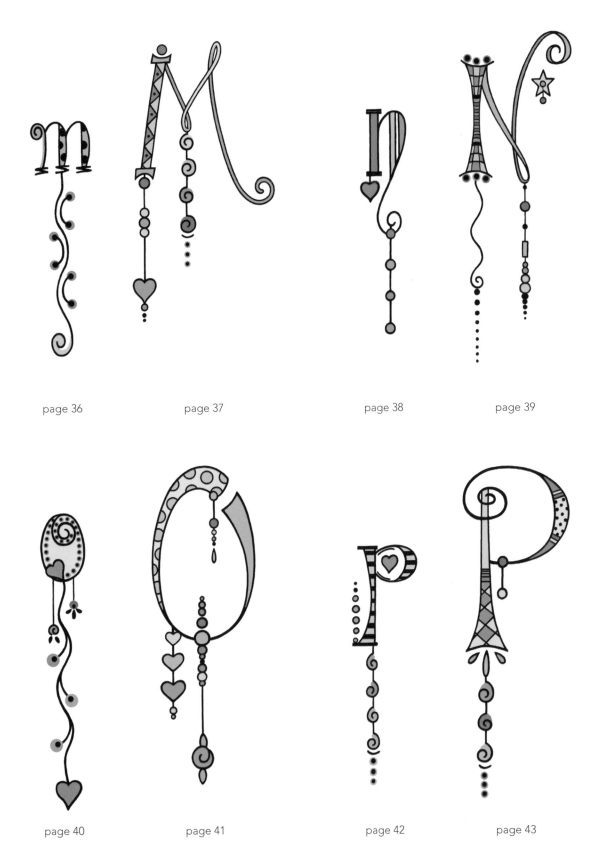

page 36

page 37

page 38

page 39

page 40

page 41

page 42

page 43

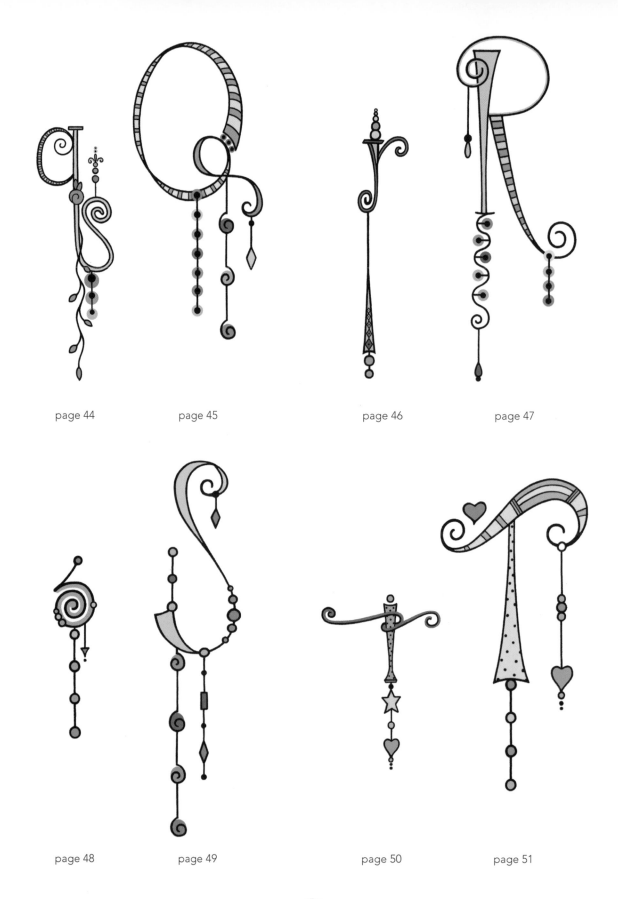

page 44 page 45 page 46 page 47

page 48 page 49 page 50 page 51

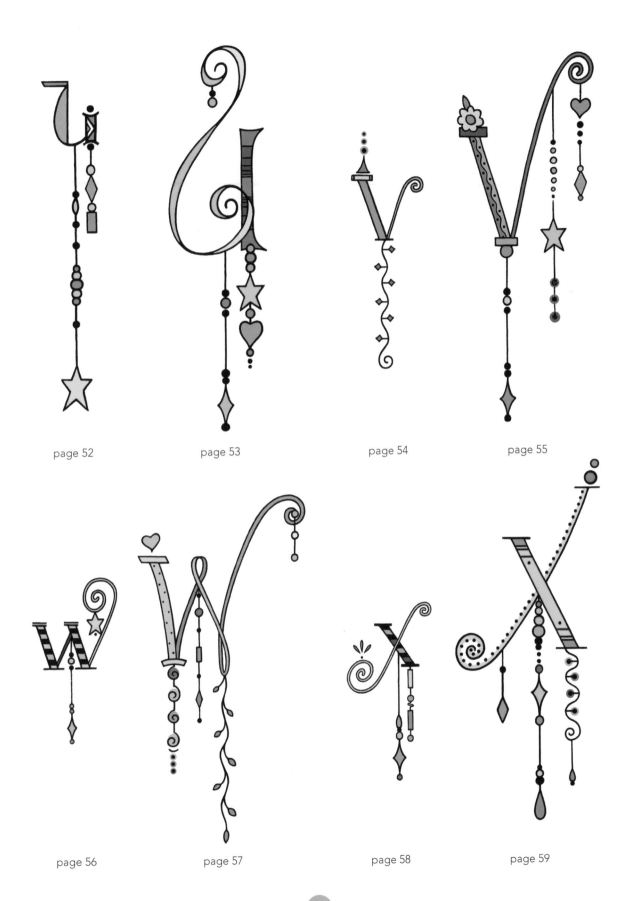

page 52

page 53

page 54

page 55

page 56

page 57

page 58

page 59

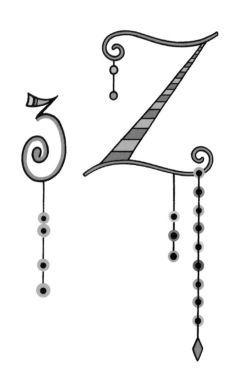

page 60 page 61 page 62 page 63

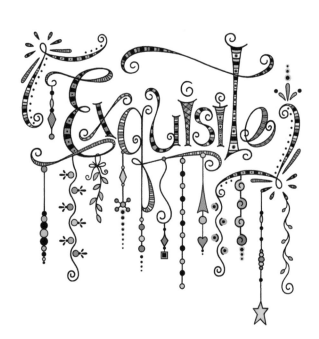

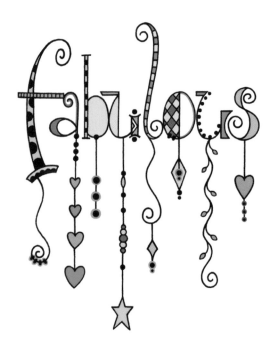

pages 66–67 pages 68–69

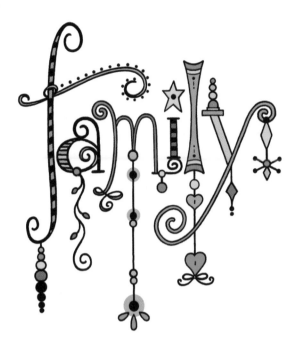

pages 70–71

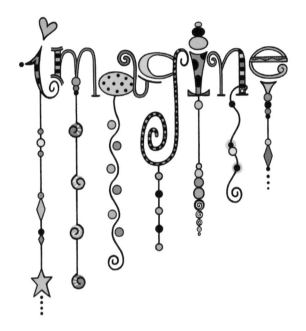

pages 72–73

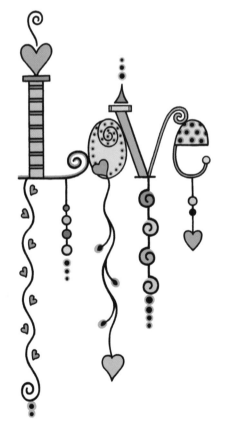

pages 74–75

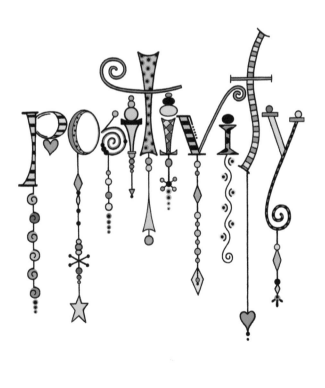

pages 76–77

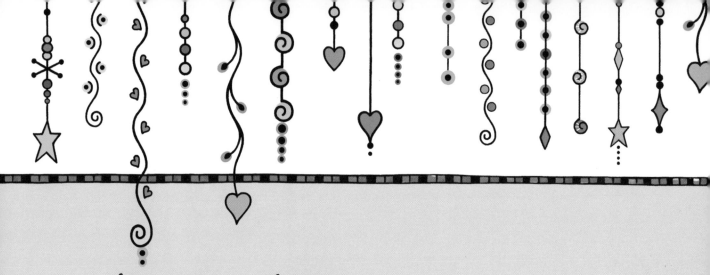

About the Author

Art has been Olivia A. Kneibler's bliss since she was a very young girl. She majored in fine art in college and then went on to create illustrations for greeting cards, invitations, promotional materials, fabric, figurines, and even plush teddy bears. After years of working with different companies such as Gibson Greetings, DecoArt, Leisure Arts, and more, she decided she would start working for herself and opened Olivia and Company (www.oliviaandco.com), where she began drawing and doodling her popular dangles.

Acknowledgments

I would like to extend a special thank you to everyone who helped to make my dangly dreams possible.

To the people at Race Point Publishing: Without you this dream would have stayed just that, a dream. Jeannine, you believed in me and encouraged me to take my dream and turn it into a charming reality. Jason, your kindness, endless hours of creativity, advice, and patience—along with your tolerance for ellipses—has helped to make this book the best it can be, which I truly appreciate. Thanks also to Merideth, Melanie, and Erin for their help making this book a reality.

To my family: Ben and children, Chris and children, Travis, Kandi and children, Chase, and Dave, thank you so much for all of your encouragement and support through this process, which has surely been the catalyst for my first step through the door and into this wonderful new world.

Thank you to everyone who has been with me over the years as a friend or patron. You've encouraged me with special notes, letting me know how much my art meant to you.

And a very special thank you to Chase and Dave who did everything within their power to help me in every way possible. Without them, I don't think I would have been able to accomplish this.